OXFORDSHIRE RAILWAYS

THROUGH TIME

Stanley C. Jenkins

AMBERLEY PUBLISHING

Acknowledgements

Thanks are due to Martin Loader (pages 5, 11, 15, 16, 26, 29, 41, 42, 70, 82, 83, 87 and 89), Mike Marr (page 88) and Kevin Tobin (page 95) for help with the supply of photographs for this book. Other images were obtained from the Lens of Sutton Collection, and from the author's own collection.

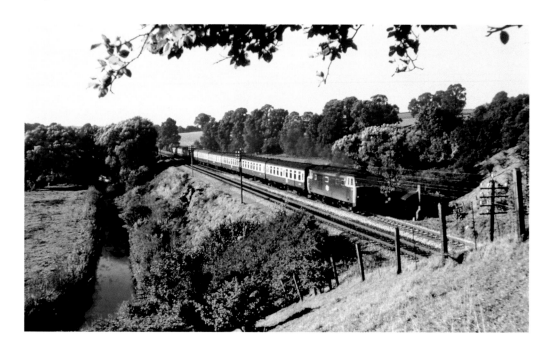

First published 2013

Amberley Publishing
The Hill, Stroud
Gloucestershire, GL5 4EP

www.amberley-books.com

Copyright © Stanley C. Jenkins, 2013

The right of Stanley C. Jenkins to be identified as the Author of this work has been asserted in accordance with the Copyrights, Designs and Patents Act 1988.

ISBN 978 1 4456 1001 6

British Library Cataloguing in Publication Data. A catalogue record for this book is available from the British Library.

Typeset in 9.5pt on 12pt Celeste.
Typesetting by Amberley Publishing.
Printed in the UK.

Introduction

The first railway to serve Oxfordshire was the Great Western (GWR) main line, which was opened from Reading to Steventon on 1 June 1840 and extended westwards to Faringdon Road on 20 July. Three years later, on 12 June 1844, the company opened a 9¾-mile branch from Didcot to Oxford, which became the starting point for two important main lines: the Oxford & Rugby Railway, which was opened from Oxford to Banbury on 2 September 1850; and the OW&WR, which was completed between Wolvercote and Evesham on 4 June 1853. Meanwhile, on 20 May 1851, the Buckinghamshire branch of the London & North Western Railway (LNWR) had been opened throughout to its terminus at Oxford Rewley Road. These early Victorian lines form the core of the present-day local railway system.

At the end of the nineteenth century, the Great Central Railway joined forces with the GWR to promote two new trunk routes to London, one of these being the GCR main line, which skirts the north-eastern corner of Oxfordshire at Finmere, while the other was the Great Western & Great Central joint route through High Wycombe to Ashendon Junction, and its north-westwards continuation to Banbury *via* Bicester – the 'Bicester Cut-off'.

Various branch lines were promoted during the Victorian period. The most important of these was the GWR branch from Twyford to Henley-on-Thames, which was opened in 1857 and has now developed as a busy commuter line. Several branch lines were closed during the 1950s and 1960s, the most significant victims being the Witney Railway, the Abingdon branch and the lengthy cross-country line between Cheltenham, Kingham and Banbury. The closure of the Witney Railway (by the road-building Transport Minister Ernest Marples) was particularly short-sighted, insofar as congestion on the busy A40 road between Oxford and Witney is now so severe that traffic often comes to a complete halt during the morning and evening rush hours.

Two of the closed lines were subsequently reopened as 'heritage railways': the Cholsey & Wallingford Railway and the Chinnor & Princes Risborough line, which, at the time of writing, normally operate as tourist attractions at weekends.

The lines are described in chronological order, starting with the GWR main line and ending with the 'Bicester Cut-off'. The sequence of opening dates is shown in the following table:

Opening Dates Of Oxfordshire Railways

Section of Line	Railway Company	Date of Opening
Reading to Goring to Steventon	GWR	1 Jun 1840
Steventon to Faringdon Road (Challow)	GWR	20 Jul 1840
Faringdon Road to Hay Lane	GWR	17 Dec 1840
Didcot to Oxford (Old Station)	GWR	12 Jun 1844
Bletchley to Banbury (Merton Street)	L&NWR	1 May 1850
Oxford to Banbury	GWR	2 Sept 1850
Claydon Junction to Islip	L&NWR	1 Oct 1850
Islip to Oxford (Oxford Road)	L&NWR	2 Dec 1850
Oxford Road to Rewley Road	L&NWR	20 May 1851
Wolvercot Junction to Evesham	OW&WR	4 Jun 1853
Kingham to Chipping Norton	OW&WR	10 Aug 1855

Abingdon Junction to Abingdon	Abingdon Railway	2 Jun 1856
Twyford to Henley-on-Thames	GWR	1 Jun 1857
Yarnton Junction to Witney	Witney Railway	13 Nov 1861
High Wycombe to Thame	Wycombe Railway	1 Aug 1862
Uffington to Faringdon	Faringdon Railway	1 Jun 1864
Thame to Kennington Junction	Wycombe Railway	24 Oct 1864
Cholsey to Wallingford	Wallingford & Watlington Railway	7 July 1866
Princes Risborough to Chinnor	Watlington & Princes Risborough Railway	15 Aug 1872
Witney Goods Junction to Fairford	East Gloucestershire Railway	15 Jan 1873
Wantage Road to Wantage Town	Wantage Tramway	11 Oct 1875
Chipping Norton to Kings Sutton	Banbury & Cheltenham Direct Railway	16 Apr 1887
Kidlington to Blenheim & Woodstock	Woodstock Railway	19 May 1890
Princes Risborough to Aynho Junction	GWR	1 Jul 1910

For the purposes of this study, the boundaries of Oxfordshire are assumed to be those which have applied since local government reorganisation in 1974; until that time, Abingdon and the Vale of the White Horse were in Berkshire. Generally speaking the lines described in this book are within the present county boundaries, although problems arise with the Oxford to Banbury line which, in places, straddles the county boundary with Northamptonshire – Aynho station, for example, was in Northamptonshire, although it served Deddington in Oxfordshire! For convenience, Aynho and Kings Sutton, both in Northamptonshire, have been included in the main route sections, whereas the following Oxfordshire stations have been omitted: Blackthorn (op. 1910), Chalcombe Road (op. 1911), Cropredy (op. 1852), Fritwell (op. 1854), Milton Halt (op. 1908) and Shrivenham (op. 1849).

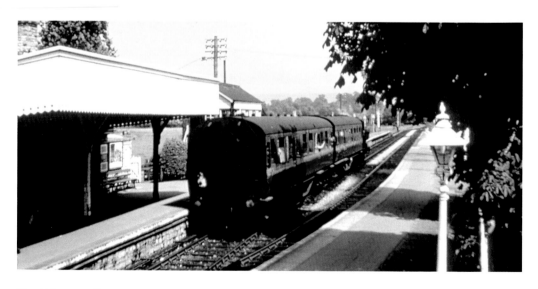

The Witney Railway
Witney passenger station in May 1961.

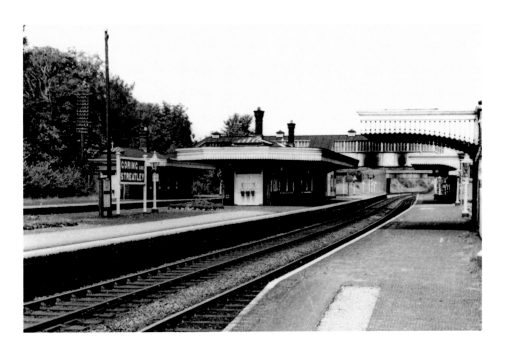

Great Western Main Line: Goring & Streatley

The GWR main line crosses the county boundary near Goring, and Goring & Streatley, 44¾ miles from Paddington, is the first station in Oxfordshire. Although this station was opened on 1 June 1840, the present station is of late Victorian origin, the layout having been rearranged when the line was quadrupled in the 1890s. The main lines are on the south side, while the up and down relief lines are to the north. Below, an 'HST' set on the quadruple-track main line near Goring. *Inset*: A British Railways (BR) Edmondson card ticket from Goring & Streatley to Cholsey & Wallingford, issued on 31 December 1963.

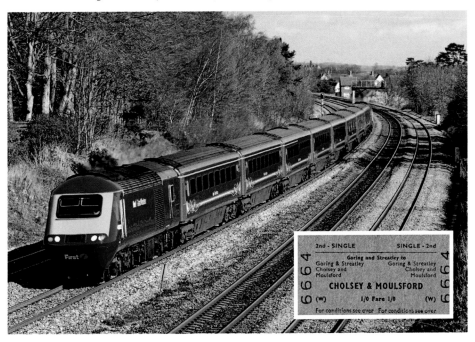

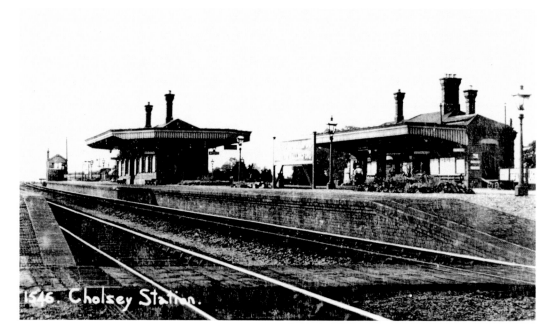

Great Western Main Line: Cholsey & Moulsford

Cholsey & Moulsford station, 48½ miles from Paddington, was opened on 29 February 1892, when it replaced an earlier station that had been sited three quarters of a mile to the east. Five platforms are provided, the main lines being on the south side, while the relief lines are to the north; an additional platform serves the Wallingford branch. The brick-built station buildings are of standard GWR design, as shown in this postcard view from around 1912. Below is the island building on platforms 2 and 3. (The canopies have now been removed.) *Inset*: A BR single ticket from Cholsey to Wallingford, issued on 10 June 1959.

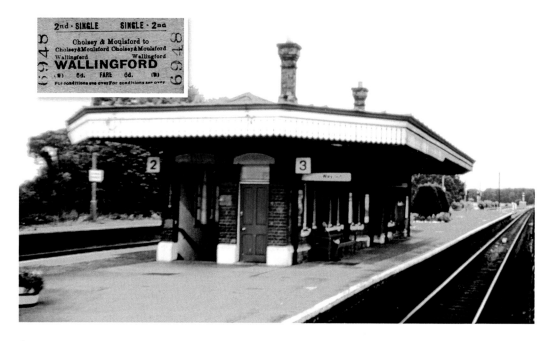

Great Western Main Line: Didcot

Opened on 1 June 1840, Didcot, 53½ miles from Paddington, handles approximately 2½ million passenger journeys per annum. Its five platforms are aligned from east to west, with the main station buildings on the south side. The upper view, from an Edwardian postcard, shows the station forecourt during the early twentieth century, while the colour photograph, which was taken from the same vantage point, shows double- and single-decker buses outside the modernised station buildings. Didcot Power Station can be seen in the distance.

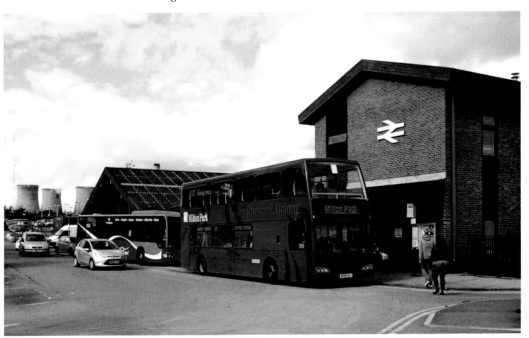

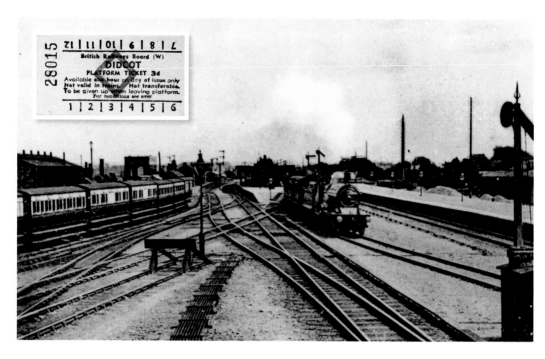

Great Western Main Line: Didcot

Above, the west end of the station is seen around 1912, with an 'Achilles' class 4-4-2 locomotive on the Bristol main line. The Oxford route diverges to the left of the picture, and Didcot engine shed can be seen in the background. The modern view looks westwards from what is now platform 3. The Oxford branch joins the main line *via* a triangular junction to the west of the platforms, while an avoiding line is provided for trains between Paddington and Oxford that do not have to call at the station. *Inset*: A BR platform ticket issued at Didcot.

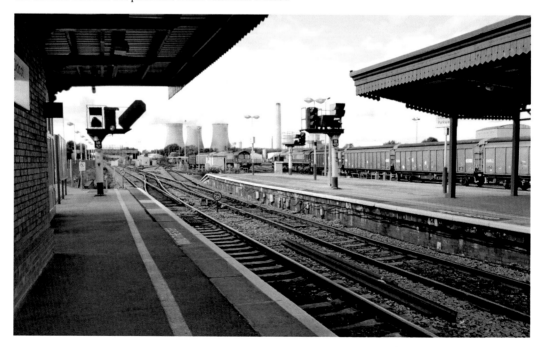

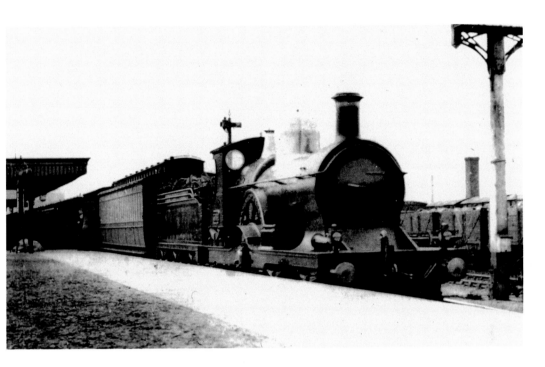

Great Western Main Line: Didcot

Another member of the 'Achilles' class waits alongside what is now platform 5, the northernmost platform, with an up train in the old image, above. Below, class '66' locomotive No. 66084 stands on the goods line to the north of the same platform. It was at one time known as platform 7, but the numbering system was altered in 1965 following the removal of two short bay platforms on the south side of the station, which had been designated platforms 1 and 2.

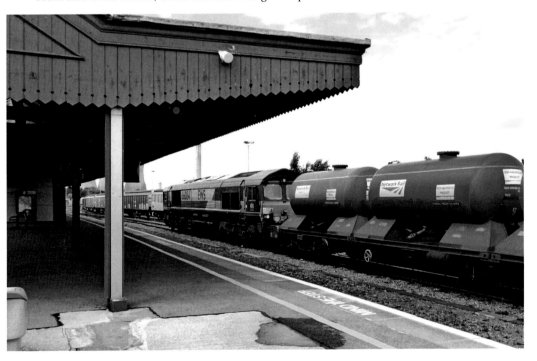

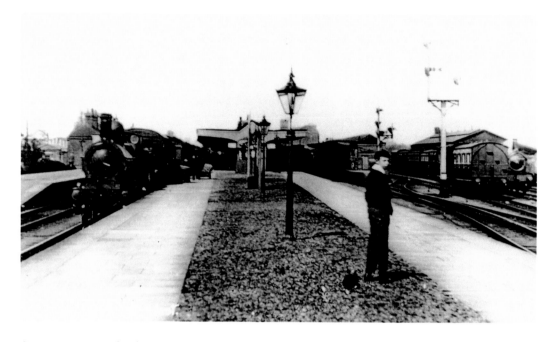

Great Western Main Line: Didcot

Above is a general view of the station, looking westwards along what are now island platforms 2 and 3, probably around 1912. Didcot engine shed was closed in 1965 but two years later the site was taken over by the Great Western Society and transformed into Didcot Railway Centre, now one of Oxfordshire's major tourist attractions. Below, '56XX' class 0-6-2T No. 6697 is seen at the Railway Centre. *Jane*, the Wantage Tramway engine, can be glimpsed in the background (*see* pp. 12–14).

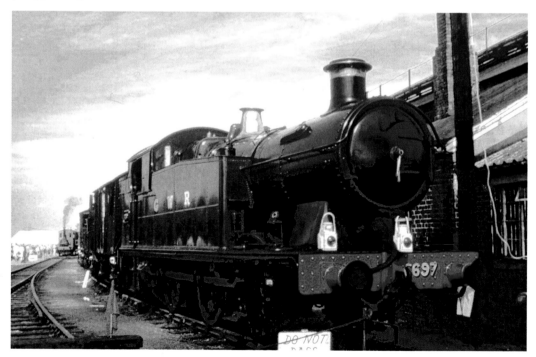

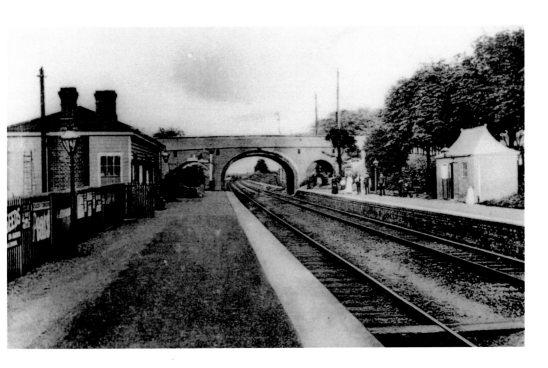

Great Western Main Line: Steventon

Heading due west from Didcot, present-day trains speed past the remains of Steventon station, 56½ miles from Paddington, which opened on 1 June 1840 and closed on Saturday 5 December 1964. The upper picture, from an old postcard, shows the station around 1912, while the colour photograph, taken by Martin Loader, shows class '66' locomotive No. 66504 passing the site of the station with a Bristol Parsons Street to Thamesport freightliner working in March 2011.

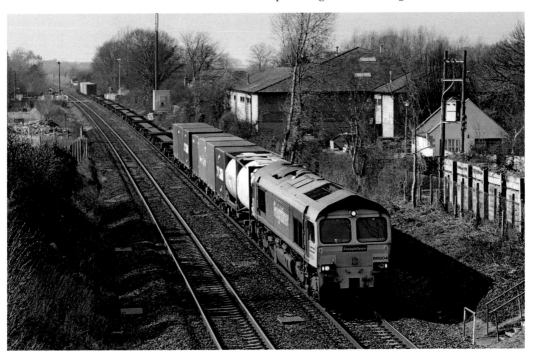

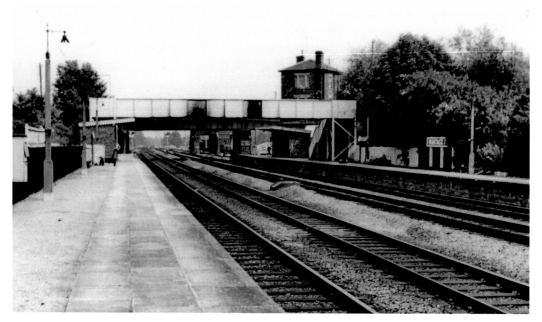

Great Western Main Line: Wantage Road

Wantage Road, 60½ miles from Paddington, was opened in November 1846 to serve the nearby town of Wantage. It became a junction on 11 October 1875, when the Wantage Tramway was opened for passenger traffic. The station was substantially rebuilt during the 1930s when the GWR quadrupled the line between Wantage Road and Challow necessitating the provision of a new platform beside the up relief line. The photograph above is looking east towards Didcot and Paddington, and was taken during the early 1960s. Wantage Road closed on 5 December 1964 and the station was then demolished. Its site can still be discerned, as shown in this recent view looking westwards from the road overbridge, taken in October 2012.

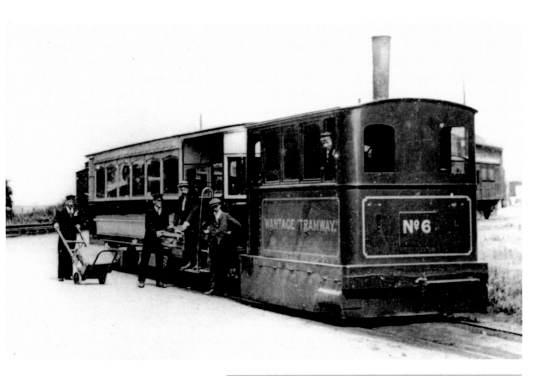

The Wantage Tramway: Wantage Road

The Wantage Tramway was opened for goods traffic on 1 October 1875 and for passengers on 11 October. The tramway commenced in the goods yard of the GWR station and for much of its length this 2½-mile line was laid alongside the main A338 road. At Wantage, the tramway came to an end in a somewhat cramped terminus known as Wantage Town station, while a goods branch diverged from the main line at Grove Road Crossing and terminated in a goods yard known as the Lower Yard. The Wantage Tramway lost its passenger services on 31 July 1925, but freight traffic was carried until December 1945. The upper photograph shows tram engine No. 6 and passenger car No. 4 in Wantage Road goods yard around 1912, while the recent picture, taken from a position slightly further to the south, shows part of the former tramway route.

13

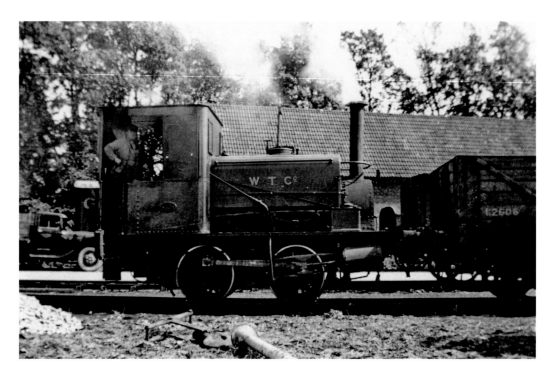

The Wantage Tramway: Jane & Mary at Wantage

Two additional views of the tramway during the 1930s showing WTC locomotives Nos 5 and 7, known colloquially as *Jane* and *Mary* respectively. The upper view shows *Mary* (built 1888) during shunting operations in Wantage Lower Yard, while the lower view shows *Mary* and *Jane* at Wantage Town. *Jane* (built 1857) was at that time out of use and had probably been brought into the sunlight to be photographed. This venerable locomotive is now preserved at the Didcot Railway Centre.

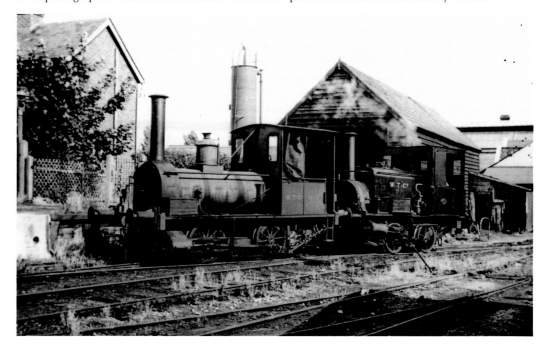

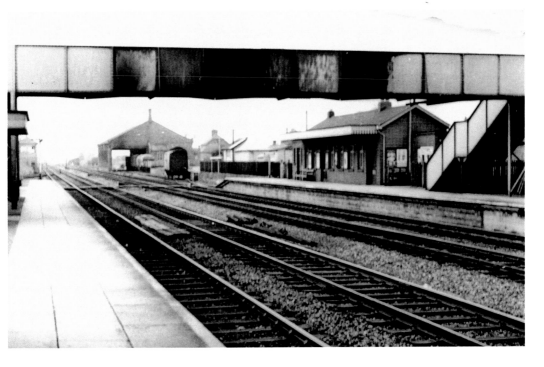

Great Western Main Line: Challow

Challow, 64 miles from Paddington, was opened as Faringdon Road on 20 July 1840; the name was changed in 1864. Along with other stations on this section of line, the station was extensively rebuilt as part of the widening operations carried out in the 1930s. Challow was closed on 5 December 1964 but its site is marked by goods loops, which can be seen in this 2012 photograph of class '66' locomotive No. 66186 entering the up loop with an empty ballast train.

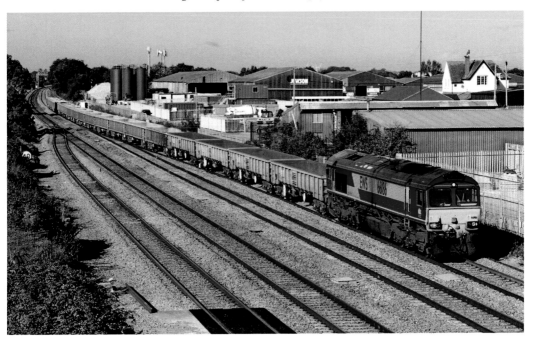

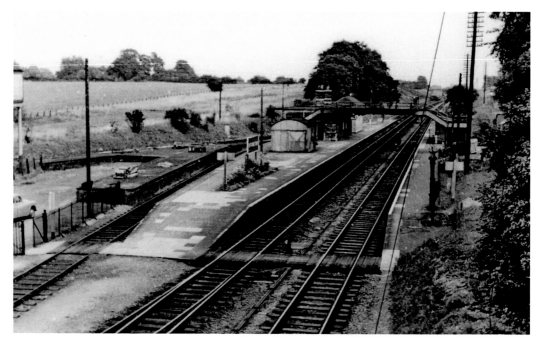

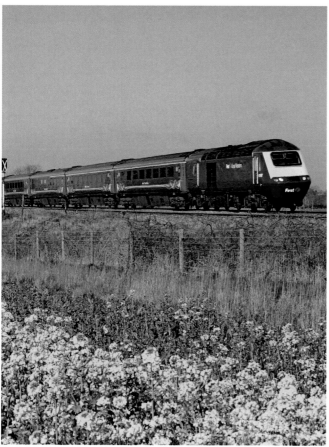

Great Western Main Line: Uffington

The next stop, Uffington (66½ miles), was opened on 1 June 1864, in connection with the Faringdon branch, which diverged on the north side. Up and down platforms were provided, the up platform being an island with tracks on either side, although the outer face was not signalled for through working. Faringdon branch trains used the eastern extremity of this third platform and the western end was regarded as a siding. The station was closed on 5 December 1964 and the buildings were demolished. This recent colour photograph by Martin Loader shows 'HST' power car No. 43092 heading the 06.45 a.m. Exeter St David's to Paddington service past a field of oilseed rape near the site of Uffington station.

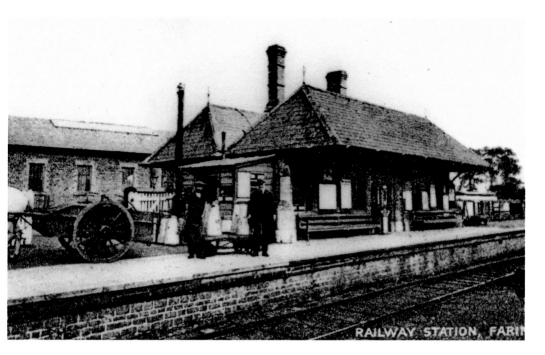

The Faringdon Branch

The Faringdon Railway was authorised by Act of Parliament on 13 August 1860, and on 1 June 1864 it opened from Uffington to Faringdon, a distance of 3½ miles. Faringdon was a typical branch-line terminus, with a run-round loop, goods yard and engine shed. The Cotswold-stone station building was a unique structure that had probably been designed by Malachi Bartlett (1802–75) of Witney – a local builder who in 1863 was awarded a contract for 'erecting the new station and goods shed at Faringdon'. The branch was closed to passengers on Saturday 29 December 1951 and to goods traffic in July 1963. The upper view, from an old postcard, depicts Faringdon's distinctive station building around 1912, while the view to the right shows this very rural terminus in its final years of operation. The site of the station has now been entirely redeveloped.

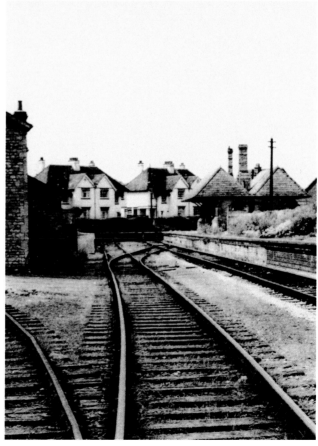

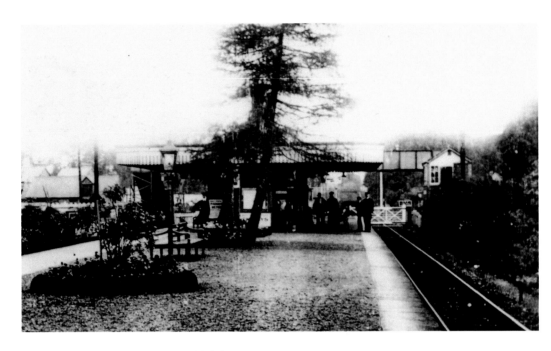

The Henley-on-Thames Branch: Shiplake

The GWR main line was the starting point for several other branch lines. The most important of these was the 4½-mile branch from Twyford to Henley-on-Thames, which was opened on 1 June 1857. This extant branch has two intermediate stations: Shiplake (2¾ miles from Twyford), is in Oxfordshire, while Wargrave, which was opened in 1907, is situated in Berkshire. Shiplake, pictured around 1912, above, and in the 1960s, below, featured an island platform, but only one line remains.

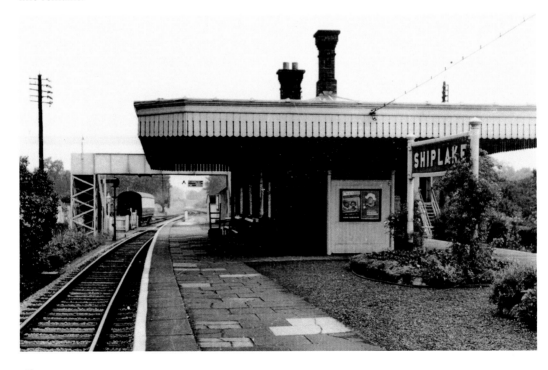

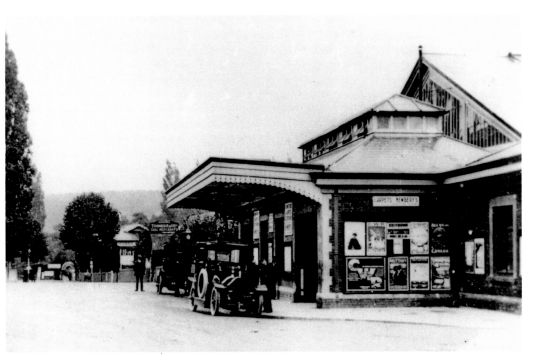

The Henley-on-Thames Branch: Henley

At Henley, journeys come to an end within easy walking distance of the River Thames, which gives the station something of the atmosphere of a 'seaside' terminus. In its heyday this riverside station boasted an overall roof and three platforms, together with a goods yard, carriage sidings and an engine shed, but the infrastructure has now been reduced to just one platform and a modern station building, although the GWR platform canopy has been retained. The upper view, from an Edwardian postcard of c. 1908, shows the exterior of the station building, while the photograph to the right shows the station around eighty years later, with a Park Royal class '103' diesel multiple unit lurking beneath the barn-like roof of the train shed.

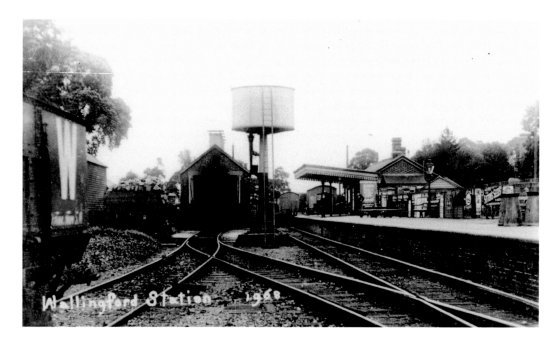

The Wallingford Branch

The Wallingford & Watlington Railway was incorporated in 1864, with powers for the construction of a railway from Cholsey to Watlington. The company was unable to complete its scheme throughout to Watlington, but a 2½-mile branch was opened between Cholsey and Wallingford on 7 July 1866. Wallingford is seen above. The line was absorbed by the GWR in 1872 and, although passenger services were withdrawn in 1959, it subsequently reopened as a heritage railway. Below is '14XX' class locomotive No. 1466 on an 'operating day' in 1968. *Inset*: A return ticket to Wallingford, issued in connection with a special operating day on 15 April 1968.

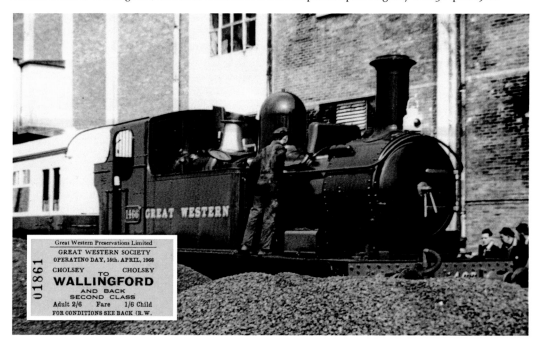

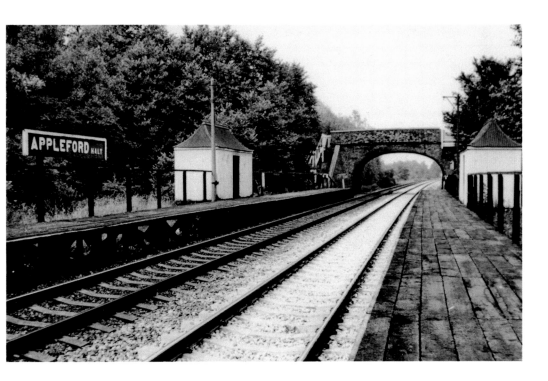

Great Western Oxford Branch: Appleford Halt

When it opened from Didcot to Oxford on 12 June 1844 the Oxford line was regarded as a 'branch', but the line was subsequently extended to Birmingham and Worcester and thereby became part of an important main line. Travelling northwards from Didcot, Appleford Halt, opened on 11 September 1933, is the first intermediate stopping place. The upper view shows Appleford in the 1960s, while the colour photograph was taken in October 2012; both photographs are looking north towards Oxford.

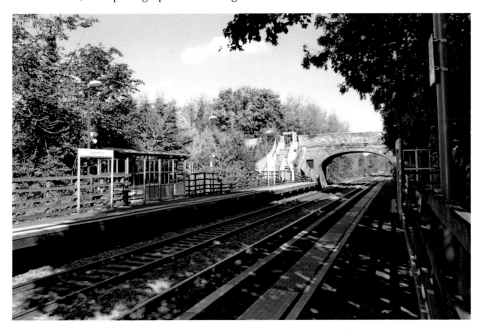

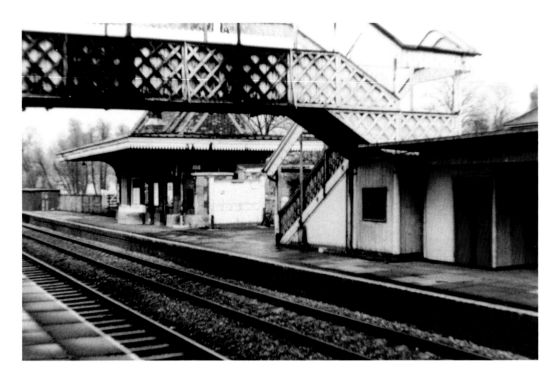

Great Western Main Line: Culham

Culham, 3 miles to the north of Didcot, was opened on 12 June 1844. Its two platforms are connected by a footbridge. Although now an unstaffed halt, the original Brunel-designed station building remains intact on the up side. The upper picture was taken in 1973, while the lower illustration shows the station in 2012. In September 1939 Culham was one of the designated reception stations in the GWR London Evacuation Scheme and as such it received around 4,000 evacuees.

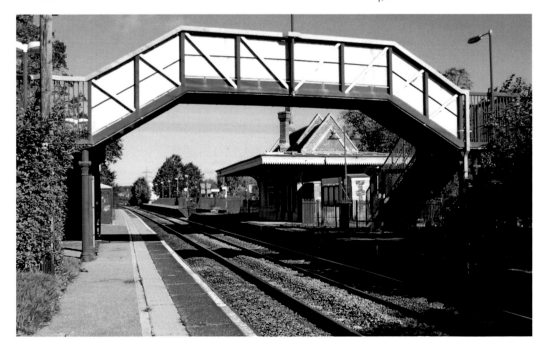

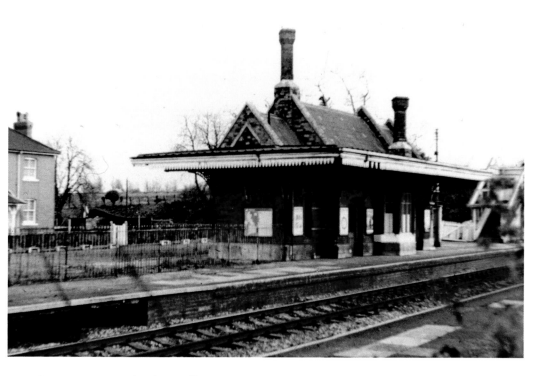

Great Western Main Line: Culham

The above view of Culham's historic Brunelian station building dates from April 1973. The stationmaster's house is visible to the extreme left. The recent photograph below was taken from the station forecourt and showing the rear of the station building. Comparison of these two photographs will reveal that a considerable amount of renovation and general tidying-up work has been carried out in recent years.

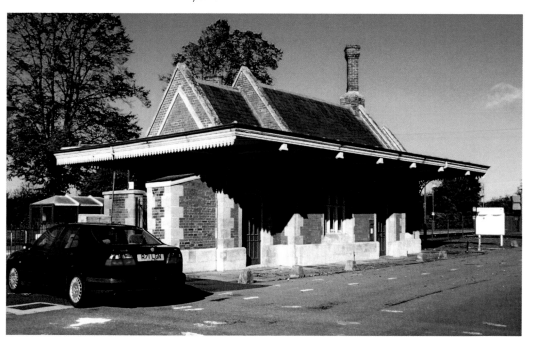

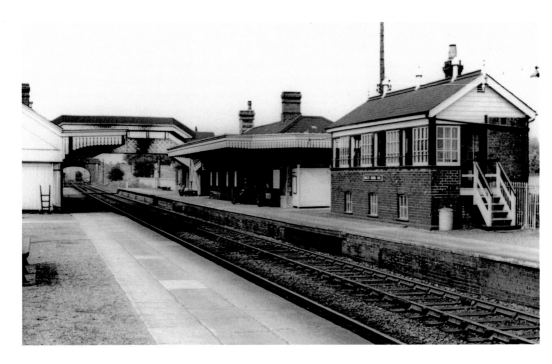

Great Western Main Line: Radley

Unlike Culham, Radley, 5¼ miles from Didcot, is not an original station. It opened on 8 September 1873 to replace an earlier station known as Abingdon Junction. Prior to rationalisation, the station had boasted up and down platforms for through traffic and an additional platform for Abingdon branch trains, together with a goods yard and substantial red-brick station buildings. Although now unstaffed, it remains a relatively busy station, generating about 70,000 passenger journeys per annum.

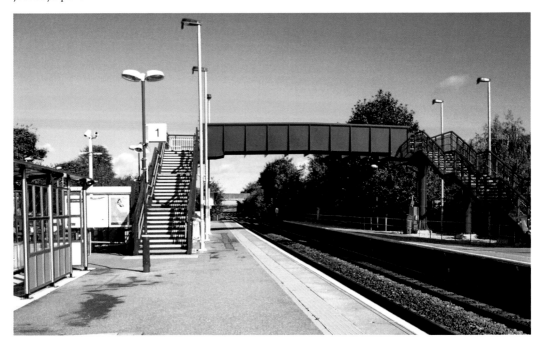

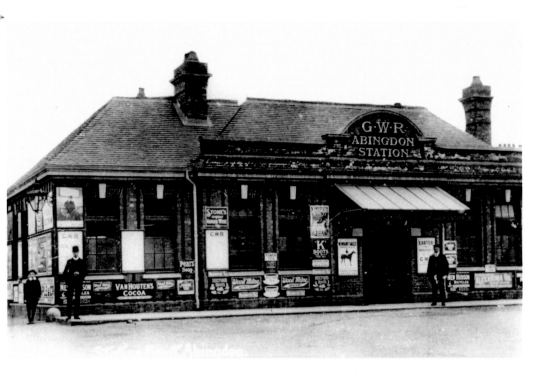

The Abingdon Branch

The Abingdon Railway was opened from Abingdon Junction to Abingdon, a distance of 1 mile 70 chains, on 2 June 1856. The line, originally broad gauge, was converted to standard gauge in 1872. At the same time the original junction was abolished and the branch was extended northwards alongside the main line to Radley. Passenger services were withdrawn in 1963 but goods traffic continued until 1984. The upper view depicts the station building around 1912, while the lower view shows the platform around 1963. *Inset*: An early BR 'privilege' ticket from Abingdon to Birmingham, issued on 23 March 1953.

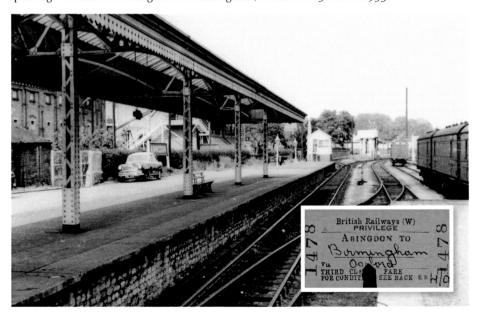

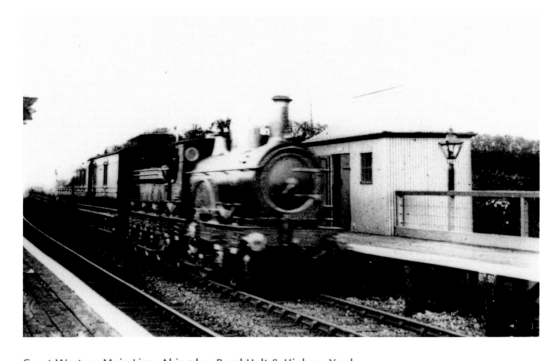

Great Western Main Line: Abingdon Road Halt & Hinksey Yard

On 1 February 1908 a new stopping place was opened beside the Abingdon Road Bridge, 1½ miles to the south of Oxford station. In the event its life was very short, and the halt, seen above, was closed as a wartime economy measure in March 1915. However, in 1942 the Hinksey area, immediately to the north of the abandoned halt, became the site of a wartime marshalling yard. The yard has remained in use, as shown in this recent photograph by Martin Loader.

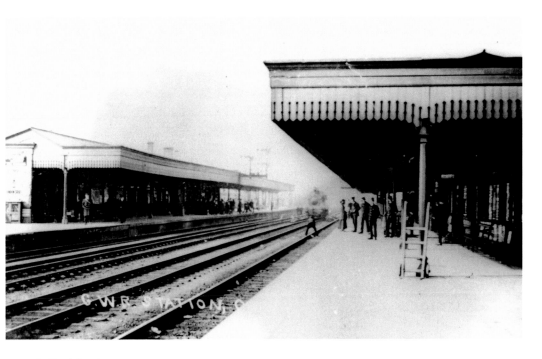

Oxford Station

The railway reached Oxford on 12 June 1844, the first station being a small terminus in St Aldate's. The line was extended to Banbury on 2 September 1850, but the existing Oxford station was not opened until 1 October 1852 when the Oxford to Birmingham main line was completed throughout. This second station had a quadruple-track layout, as depicted in this view from around 1912. The station buildings were of wooden construction, as shown in the lower photograph from around 1958. *Inset*: A child's BR cheap day return ticket from Oxford to Banbury, issued on 29 July 1964.

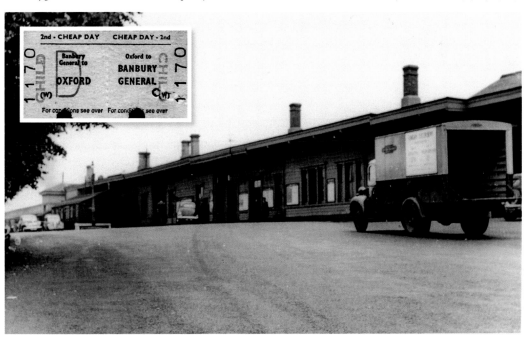

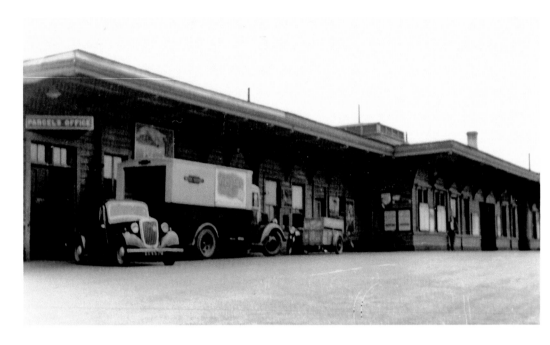

Oxford Station

The main station building, on the up side, boasted a range of accommodation including waiting rooms, booking office, refreshment room, parcels office, stationmaster's office, mess rooms and toilets. The up and down platforms were linked by an underline subway and lengthy canopies were provided on both sides. The station was rebuilt in 1971 and again in 1990. The present station has substantial modern buildings, as shown in the recent photograph, which was taken from the pedestrian footbridge across the Botley Road.

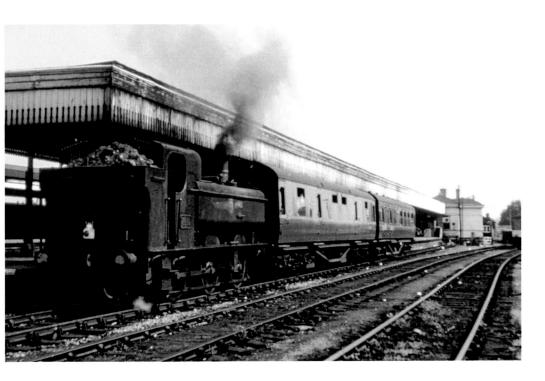

Oxford Station

In steam days, the station was equipped with bay platforms on both sides. The down bay was removed in the 1970s, but the up bay survived and has remained in use as platform 3. The upper photograph shows a Fairford-branch train in the down bay in 1962, while the lower view provides a general view of the south end of the present-day station; an 'HST' set is visible to the right, while 'Voyager' unit No. 220022 arrives with the 13.45 Bournemouth to Manchester Piccadilly service.

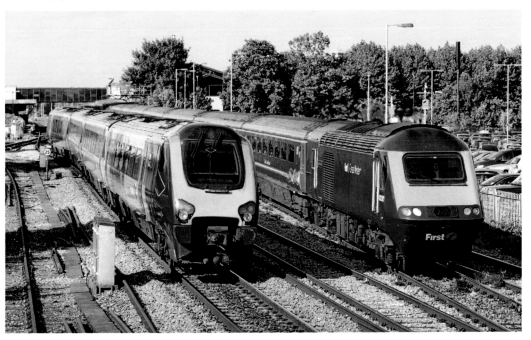

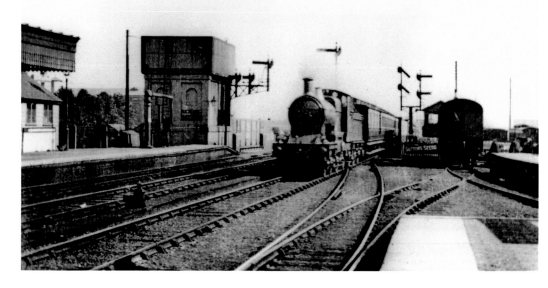

Oxford Station: Famous Locomotives

These contrasting views show steam locomotives at Oxford. The upper view is of a re-boilered 'Achilles' class 4-2-2 single-wheeler passing through the station with an express train around 1912, while the lower view shows 'King' class locomotive No. 6000 *King George V* on the down through-line with the Bulmer's cider train, on 2 October 1971. Steam locomotives had been banned from the main-line system in 1968, but the appearance of the cider train heralded a welcome revival of steam operation.

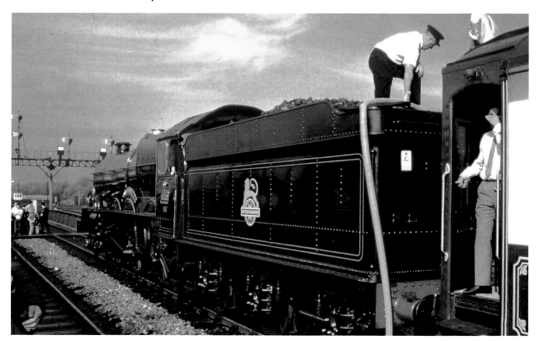

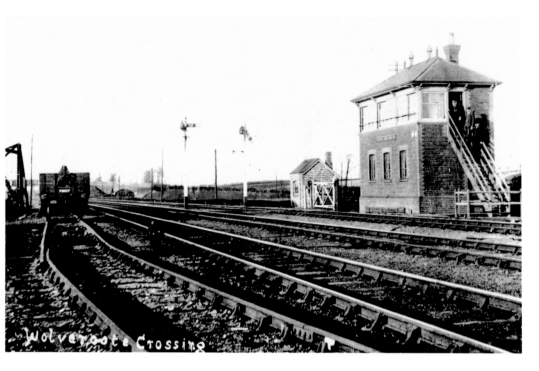

The Oxford & Rugby Line: Wolvercot Halt & Siding

Wolvercot Junction, 2½ miles to the north of Oxford, marks the point of bifurcation between the Oxford & Rugby route and the Oxford, Worcester & Wolverhampton lines. A halt known as Wolvercot Platform, shown in the above photograph, was situated some 47 chains to the south of the junction. It opened on 1 February 1908 and closed as a wartime economy measure in January 1916. Below, a Paddington to Worcester express diverges north-westwards onto the OW&WR route at Wolvercot Junction in 1971.

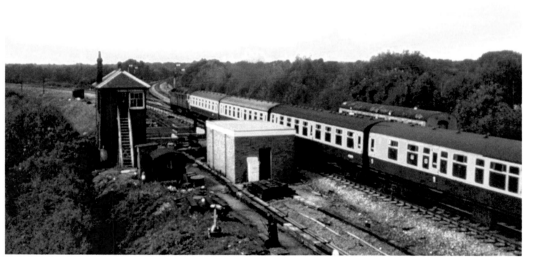

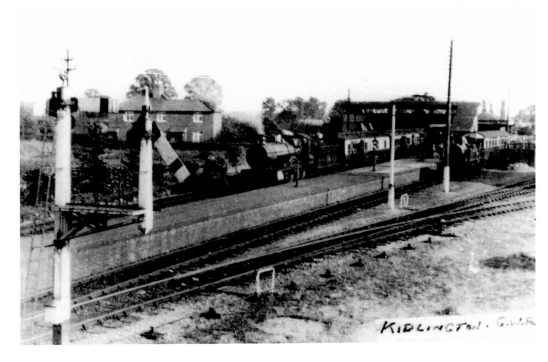

The Oxford & Rugby Line: Kidlington

Kidlington station, 5¾ miles to the north of Oxford on the Oxford & Rugby line, was opened on Friday 1 June 1855. The station was at one time known as Woodstock Road, the name being changed on 19 May 1890 when Kidlington became the junction for branch-line services to Blenheim & Woodstock. Kidlington was closed on 31 October 1964 and the lower picture shows the station in a derelict condition in 1973. The station buildings have now been demolished.

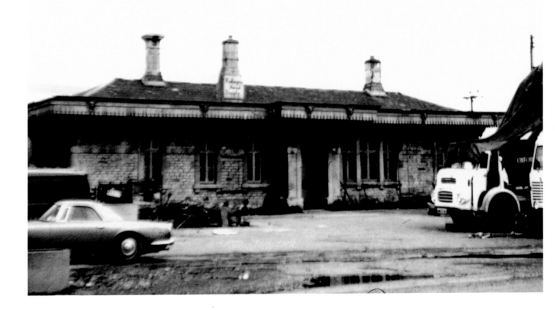

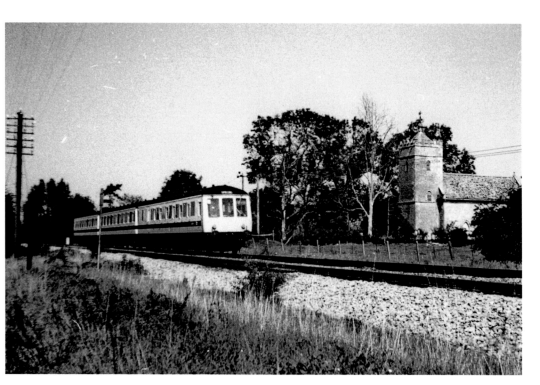

The Oxford & Rugby Line: The Hampton Gay Train Crash

On Christmas Eve 1874, Hampton Gay, between Kidlington and Bletchington, was the scene of a train crash in which thirty-four people lost their lives. The dead and dying were carried to Hampton Gay manor house and an adjoining paper mill, which was pressed into service as a morgue. The house was burned down in 1887, and local people said that the place was cursed – yet it is a pleasant enough walk across the fields from Shipton-on-Cherwell to the church and manor house. The upper view shows Hampton Gay church with the railway in the foreground. There were formerly three tracks on this section of the line, the Woodstock branch being laid alongside the still-extant up and down main lines. The lower picture, which appeared in *The Illustrated London News* on 2 January 1875, purports to show a Victorian lady identifying a dead relative in the paper mill.

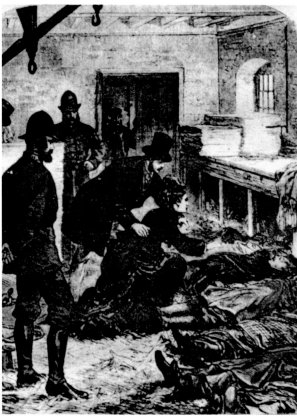

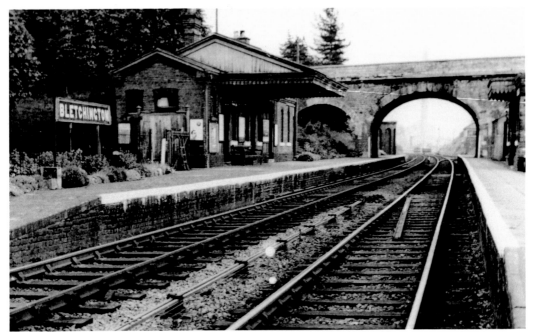

The Oxford & Rugby Line: Bletchington

Bletchington, 7½ miles to the north of Oxford, was opened on 2 September 1850. It was originally known as Woodstock Road, but the name was changed in 1855 to Kirtlington, and again in 1890 to Bletchington. The upper picture, taken around 1962, shows the red-brick station building and the triple-arched road overbridge. The station was closed on Saturday 31 October 1964 and the site has now been cleared as shown in the recent colour photograph.

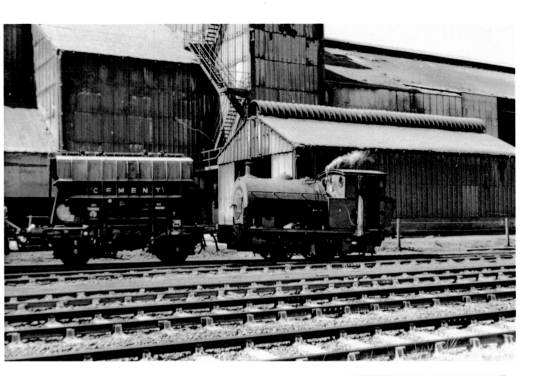

The Oxford & Rugby Line: The Shipton Cement Works Railway In 1929 a cement works was opened at Shipton-on-Cherwell by the Oxford & Shipton Cement Company. The works, 45 chains to the south of Bletchington station, was served by an extensive private railway system that was worked by a diverse collection of 0-4-0 and 0-6-0 saddle tank locomotives, including No. 5 *Westminster*, which had once been used on the Fovant Military Railway in Wiltshire, and No. 6 *C.F.S.*, a 26-ton industrial shunter built by Robert Stephenson & Co. of Newcastle. Seen above, the cement railway had its own reception loop and exchange sidings, the connections to the GWR system being controlled from a gable-roofed signal cabin sited on the up side of the main line. To the right is a detailed view of locomotive No. 3. Sadly, the cement works has closed, the sidings have been removed, and the ruined and abandoned buildings are inaccessible.

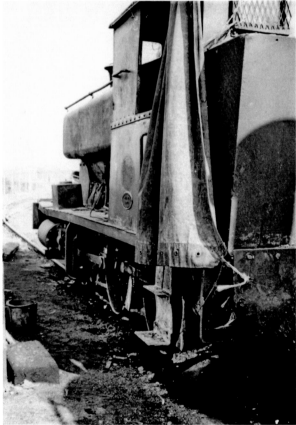

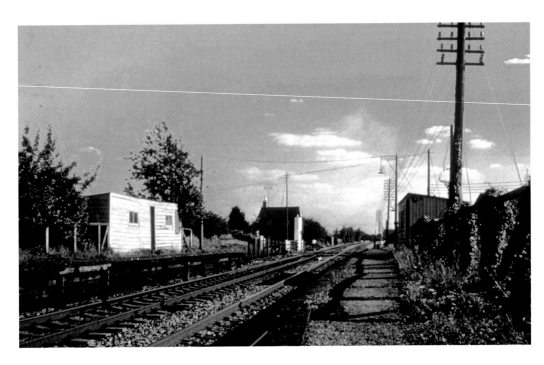

The Oxford & Rugby Line: Tackley Halt

Tackley Halt (9 miles) was opened on 6 April 1931 to serve the village of Tackley, which had not hitherto enjoyed the advantages of rail transport. Although designated a 'halt', Tackley was formerly staffed, a small ticket office being provided. Tackley remains in operation as part of the rail network, and in recent years it has generated about 19,000 passenger journeys per annum. The upper view shows the halt around 1970, looking south, while the recent view is looking north towards Banbury.

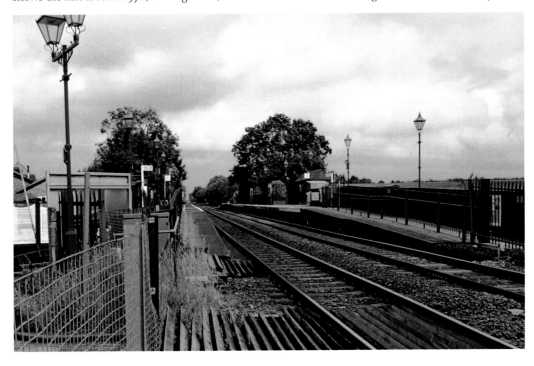

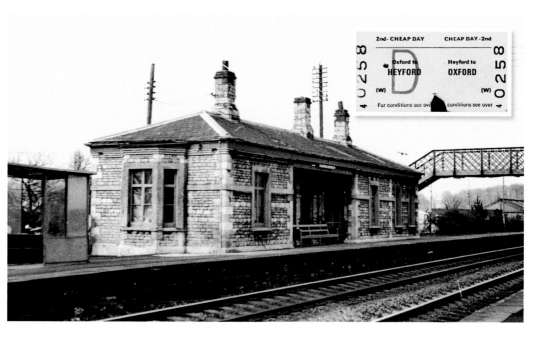

The Oxford & Rugby Line: Heyford

Heyford station, 11¾ miles to the north of Oxford, was opened on 2 September 1850. It was one of the original stopping places on the Oxford & Rugby line and, as such, it was equipped with Brunel-designed station buildings that were clearly in the same architectural 'family' as those at Kidlington and Aynho. These contrasting views show the down platform around 1970 and in 2012. The station buildings have been replaced by simple waiting shelters, although the footbridge has been renewed. *Inset*: A BR cheap day return ticket from Heyford to Oxford, issued on 28 June 1971.

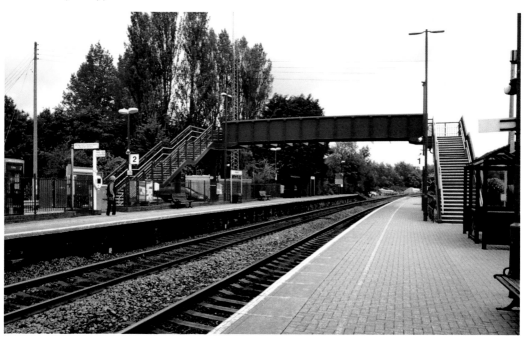

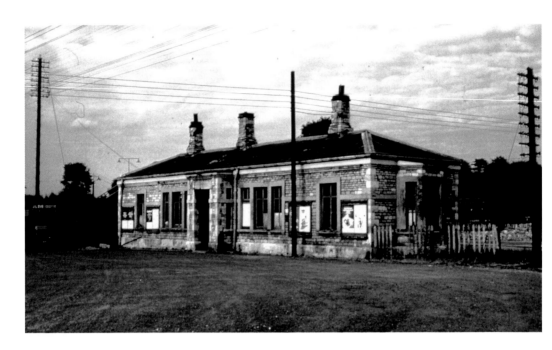

The Oxford & Rugby Line: Heyford

The upper view shows the rear of the station building around 1970, while the lower view was taken in 2012 from the footbridge, looking north towards Banbury. The Oxford Canal, which can be seen to the right, was incorporated by Act of Parliament in 1769, the engineers being James Brindley and Samuel Simcock. It opened between Hawkesbury Junction and Banbury by 1778. The canal was extended to Oxford in 1789/90, and although rapidly eclipsed by the railway, the waterway carried commercial traffic until the 1950s.

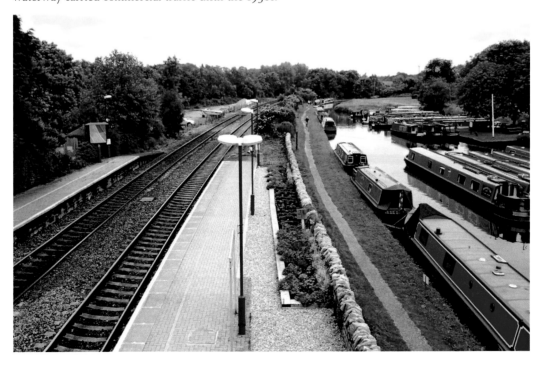

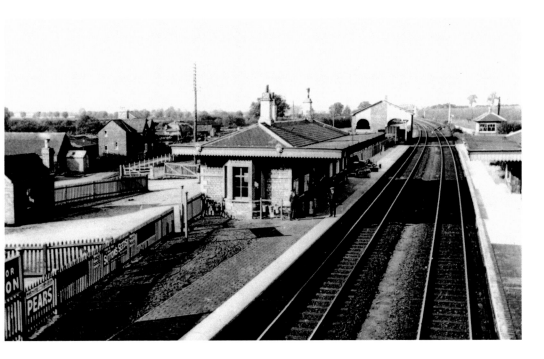

The Oxford & Rugby Line: Aynho for Deddington

The railway enters Northamptonshire at Aynho (17¼ miles). The station itself was in Northamptonshire, although Deddington is in Oxfordshire. Aynho for Deddington was one of the original stations on this line, having been opened, together with Bletchington and Heyford, on 2 September 1850. Above, a postcard view looking north towards Banbury around 1912. Aynho was closed in 1964, but the Brunelian station building survived for many years as a coal merchant's office, as seen below.

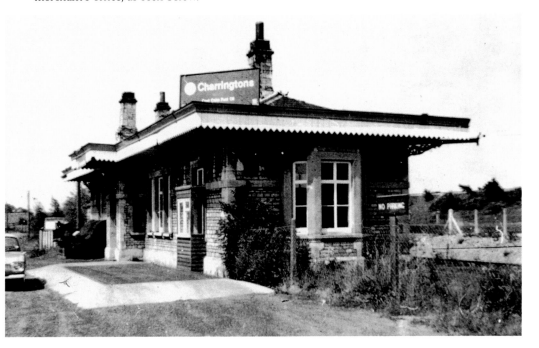

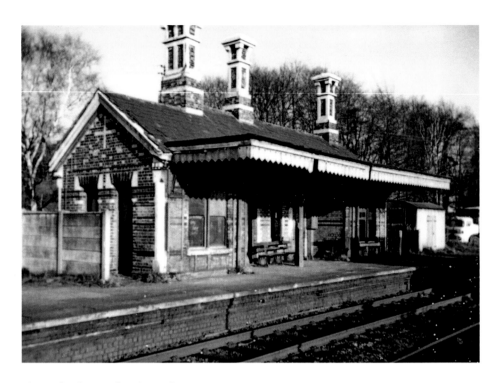

The Oxford & Rugby Line: Kings Sutton

Opened on 1 December 1873, King's Sutton (19¼ miles) boasted an ornate, Italianate-style station building, which can be seen in the upper photograph, taken around 1970. The Banbury & Cheltenham branch converged with the main line at the south end of the station, while the up and down platforms were linked by a lattice girder footbridge. Below, in October 2012, a northbound 'Voyager' passes through the station, while a class '165' unit occupies the up platform.

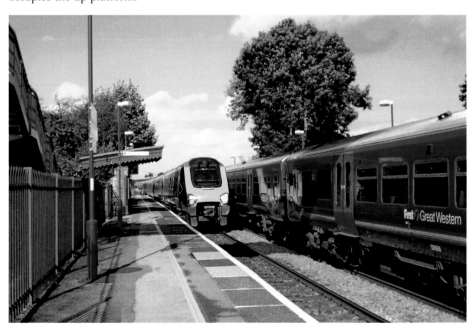

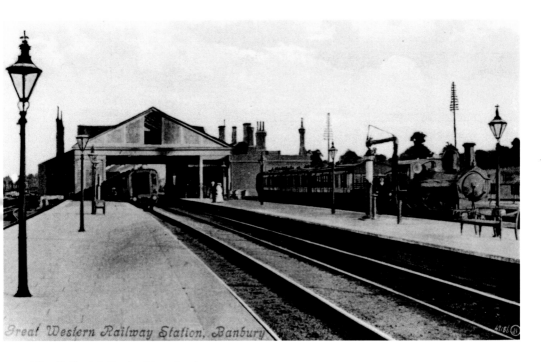

Great Western Railway Station, Banbury

The Oxford & Rugby Line: Banbury

The railway re-enters Oxfordshire on the approaches to Banbury. Opened on 2 September 1850, Banbury had originally featured two platforms and a typical Brunel-style overall roof, as shown in this postcard from *c.* 1912. The station was enlarged around 1903, and totally rebuilt in 1957, when extensive new buildings were erected. The main block is constructed of concrete with yellow-brick infilling. Below, 'HST' power car No. 43031 stands in platform 2 of the rebuilt station with a diverted Paddington to Carmarthen service, in 2011.

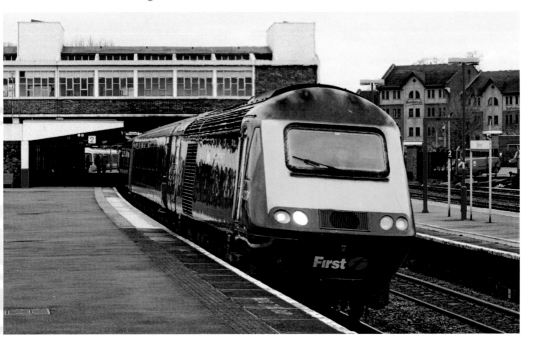

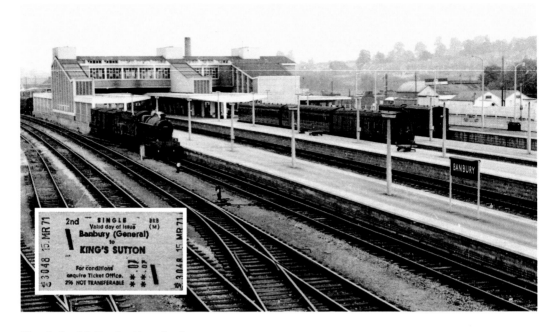

The Oxford & Rugby Line: Banbury

Two further views of Banbury's rebuilt station. The upper photograph dates from around 1962, while the recent view shows class '165' unit No. 165024 and class '52' locomotive D1015 *Western Champion* with a tour train from Didcot to Blaenau Ffestiniog. The booking hall is situated on the down side, and the up and down sides of the station are physically connected by a 40-foot wide, fully-enclosed footbridge that is spacious enough to contain an information office and a coffee shop. *Inset*: A 'multiprinter' machine second-class single ticket from Banbury to Kings Sutton, dated 15 March 1971; these modern tickets were similar to traditional Edmondson card tickets.

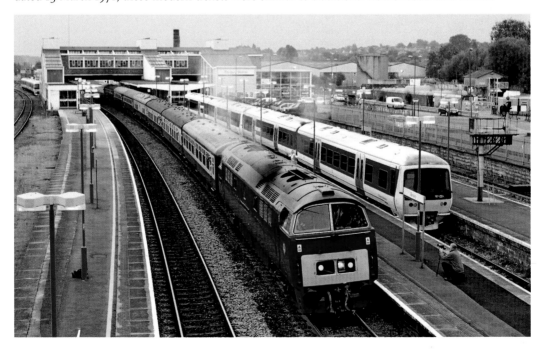

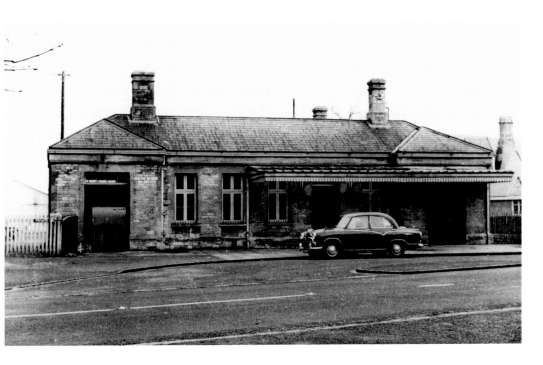

The Blenheim & Woodstock Branch: Woodstock Station

The Blenheim & Woodstock branch was constructed by the Woodstock Railway Company and opened on Monday 19 May 1890. The railway had been financed largely by the Duke of Marlborough, but it was worked from its inception by the GWR, which purchased the line in 1897. The railway commenced at Kidlington, and branch trains ran alongside the main line for about a mile before diverging westwards near Shipton-on-Cherwell. The terminal building at Woodstock has latterly been adapted for residential use.

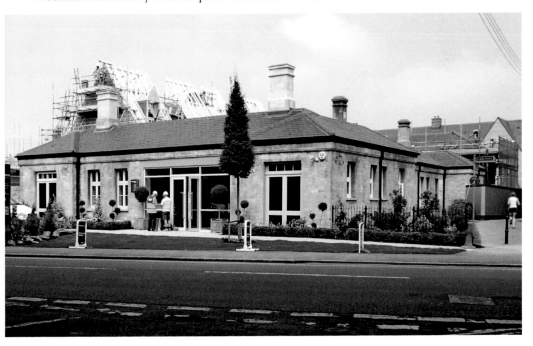

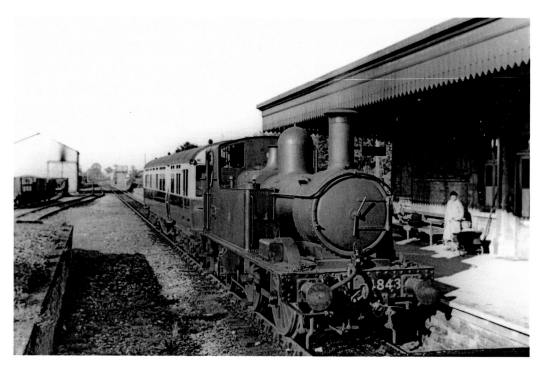

The Blenheim & Woodstock Branch: Woodstock Station

Blenheim & Woodstock station, 3 miles 57 chains from Kidlington, had a single platform for passenger traffic, together with a small goods yard with three sidings. The track layout was simplified in 1927 when the engine shed and signal box were abolished. The upper photograph shows '48XX' class 0-4-2T locomotive No. 4843 with a push-pull train in the 1930s, while the lower view shows the site of the station and goods yard in 2012, looking west towards the terminal buildings.

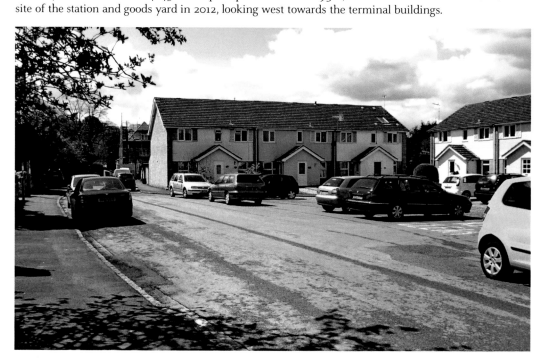

The Blenheim & Woodstock Branch: Shipton-on-Cherwell Halt

The upper photograph shows the railway embankment and the now dismantled girder bridge at Shipton-on-Cherwell. This was the site of Shipton-on-Cherwell Halt, the only intermediate stopping place on the Woodstock branch. The halt was constructed at a cost of £160 and opened on 1 April 1929. Sadly, the Blenheim & Woodstock branch closed on Saturday 27 February 1954. The last train was accompanied by a suitably attired 'mourning party' from the Oxford University Railway Society. Below is the 1923 timetable.

BLENHEIM AND WOODSTOCK BRANCH
(WORKED BY ELECTRIC STAFF.)

Single Line between Blenheim and Woodstock and Kidlington.

DOWN TRAINS—WEEK DAYS.

Distance M.C.	STATIONS.	Sta'n No.	1 B Mixed	2 B Pass.	3 K Goods	4 B Mixed	5 B Oxf'rd Pass.	6 B Pass.	7 B Pass.	8 B Pass.	9 B Pass.	10 B Pass.	11 B Pass.
			A.M.	A.M.	A.M.	P.M.	P.M.	P.M.	P.M.	P.M.	P.M.	P.M.	P.M.
	Kidlington dep.	126	8 22	9 53	10 40	12 8	2 31	3 57	4 57	5 45	6 44	8 37	9 24
3 56	Blenheim & Woodstock arr.	180	8 32	10 0	10 50	12 18	2 41	4 5	5 5	5 53	6 52	8 45	9 32

UP TRAINS—WEEK DAYS.

Distance M.C.	STATIONS	Sta'n No.	1 B Pass.	2 B Pass.	3 K E & V	4 B Mixed Pass.	5 B Oxf'rd Pass.	6 B Mixed	7 B Pass.	8 K Goods and C'ch's	9 B Mixed	10 B Pass.	11 B Pass.
			A.M.	A.M.	A.M.	A.M.	P.M	P.M.	P.M.	P.M.	P.M.	P.M.	P.M.
	Blenheim and Woodstock dep.	126	7 52	9 23	10 13	11 22	1 7	3 25	4 35	5 20	6 15	8 17	9 0
3 56	Kidlington arr.	180	8 0	9 31	10 20	11 32	1 15	3 37	4 43	5 30	6 25	8 25	9 8

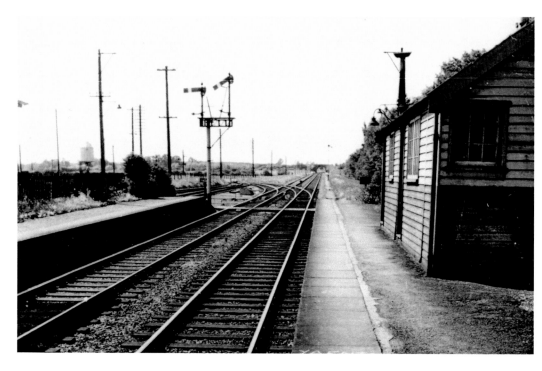

Oxford, Worcester & Wolverhampton Line: Yarnton Junction

Yarnton Junction, at the southern extremity of the OW&WR line, was opened in conjunction with the Witney Railway on 13 November 1861. It was laid-out as the three-platform station, although the outer 'branch' platform line was fenced-off and used as a siding. A marshalling yard was constructed on the down side during the Second World War, but no public goods facilities were provided. Yarnton was closed on Saturday 16 June 1962 and its site is now obscured by trees and bushes, as seen below.

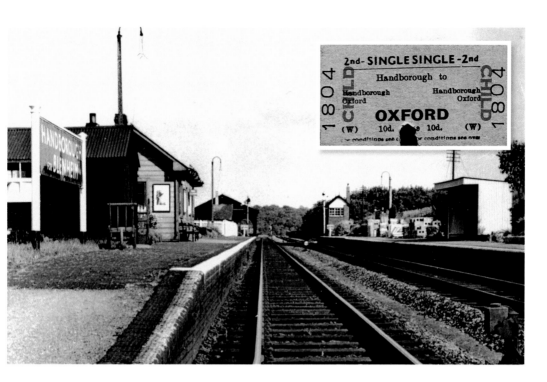

Oxford, Worcester & Wolverhampton Line: Handborough for Blenheim

Handborough station, 7 miles from Oxford, was opened by the OW&WR on 4 June 1853. On 30 January 1965 it achieved national fame when the body of wartime Prime Minister Sir Winston Churchill was brought by special train from Waterloo for private burial in nearby Bladon churchyard. The special was hauled by 'Battle of Britain' class locomotive No. 34051 *Winston Churchill*. This station has remained in operation as an unstaffed halt as shown in the recent photograph. *Inset*: A child's BR second-class single ticket from Handborough to Oxford, issued on 14 September 1963.

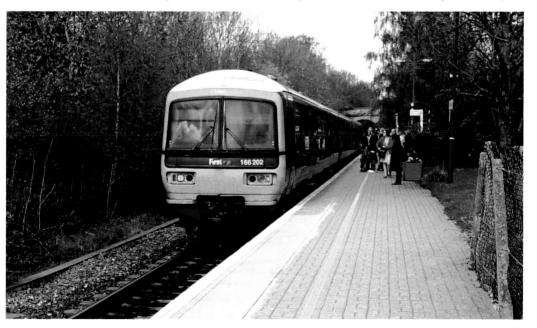

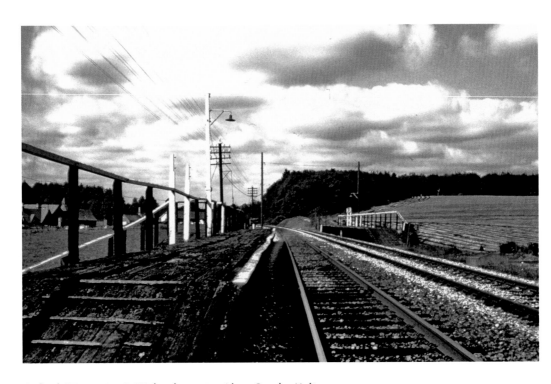

Oxford, Worcester & Wolverhampton Line: Combe Halt

Combe Halt, 8¼ miles from Oxford, was opened by the GWR on 8 July 1935. It was originally equipped with staggered up and down platforms and although no public goods facilities were available a private siding served the neighbouring Combe sawmill, which can be glimpsed on the extreme left of the upper photograph. The line was reduced to single track in 1971 and for this reason there is currently just one platform as shown in the lower illustration.

Oxford, Worcester & Wolverhampton Line: Finstock Halt

Finstock Halt (11¾ miles), the next stopping place *en route* to Worcester was, like Combe, a relatively late addition to the railway network, having been opened by the GWR on 9 April 1934. It was originally equipped with earth-and-sleeper platforms and arc-roofed waiting shelters, as shown in the upper illustration, but the former up platform was taken out of use when the line was reduced to single track in 1971. The colour photograph, which was taken from the road overbridge in 2012, shows Finstock Halt in its present form, with a single platform and a modern waiting shelter. This modest station dealt with 1,297 passengers in 2005/06, rising to 1,984 in 2011/12.

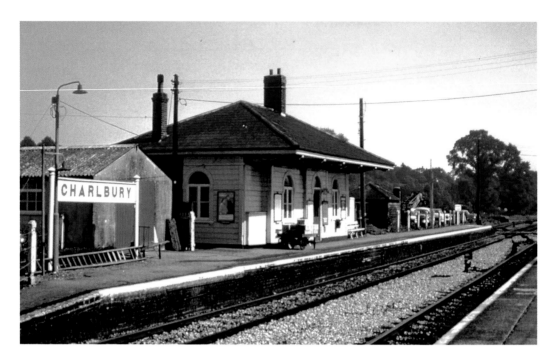

Oxford, Worcester & Wolverhampton Line: Charlbury

Situated some 13¼ miles to the north of Oxford, Charlbury was opened by the OW&WR on 4 June 1853. Its timber-framed station building was designed in the Italianate style by Isambard Kingdom Brunel (1806–59), although Brunel had resigned from his post as OW&WR engineer before the line was completed. The station, now a listed building, is a rare example of Victorian prefabrication. The upper photograph dates from around 1968, while the lower view was taken in 2012.

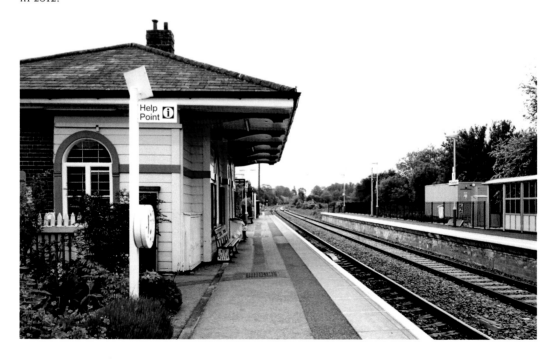

Oxford, Worcester & Wolverhampton Line: Charlbury

The upper view provides a glimpse of Charlbury's now demolished timber-built goods shed together with the signal box, which was sited on the opposite side of the running lines. In total there were three goods sidings at Charlbury. Two were in the main goods yard while an additional siding was to the west of the platforms on the up side. The station issued 18,844 tickets per year in 1903, rising to 20,989 in 1930, and then falling to 17,691 ordinary singles and returns in 1934. In recent years, the station has handled around 240,000 passengers per annum. Goods traffic was dealt with until November 1970, when the sidings were lifted to provide more room for passengers' cars. The lower view shows Charlbury station in its present form, with extended platforms and a footbridge with long ramps to accommodate wheelchair users. *Inset*: A BR second-class day return ticket from Charlbury to Oxford, issued on 16 October 1986.

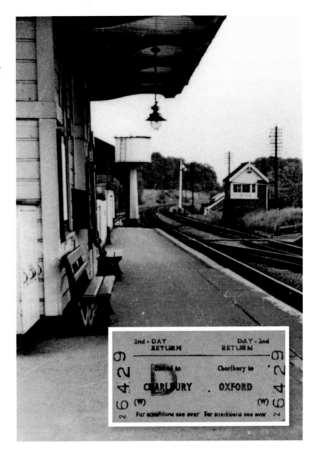

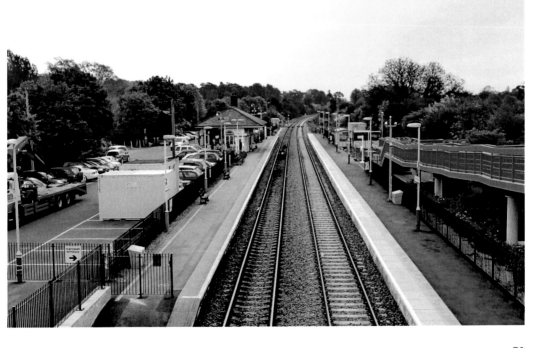

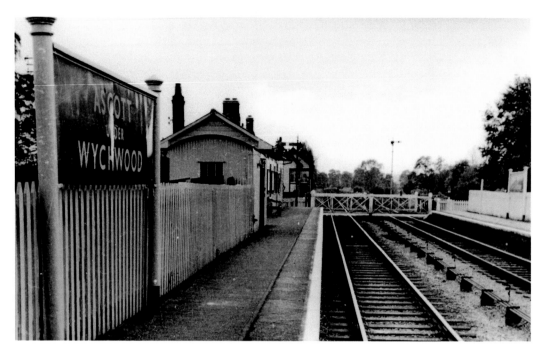

Oxford, Worcester & Wolverhampton Line: Ascott-under-Wychwood

Ascott-under-Wychwood (17 miles) was opened on 4 June 1853. Its track layout incorporated up and down platforms with a wooden station building on the down side, and a level crossing immediately to the west. The OW&WR line was partially singled in 1971, double track being retained between Ascott and Moreton-in-Marsh. However, double-track working has now been reinstated between Ascott and Charlbury, necessitating the provision of a new up platform, which can be seen to the right in the lower photograph.

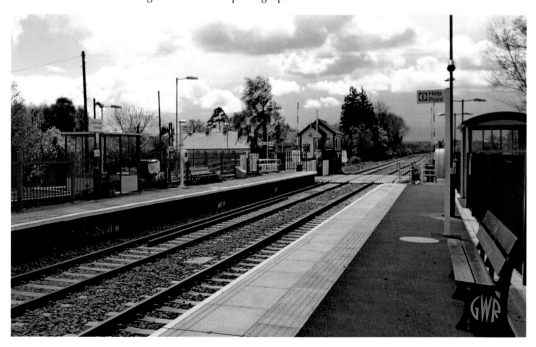

Oxford, Worcester & Wolverhampton Line: Shipton-for-Burford

When opened on 4 June 1853, Shipton-for-Burford station (18¼ miles) had been similar to Ascott-under-Wychwood, but its original wooden station buildings were replaced in the late Victorian period, when the GWR constructed a new brick-built station building in its then standard hip-roof style, with tall chimneys and a projecting canopy. There was a fully equipped goods yard, while a private siding served the adjacent flour mill. Shipton remains in operation as a passenger-only stopping place, although its buildings have been demolished.

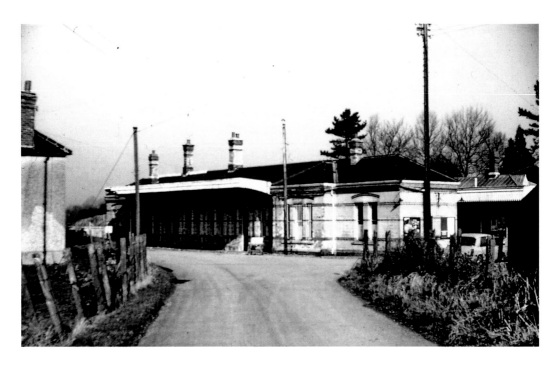

Oxford, Worcester & Wolverhampton Line: Kingham

Kingham, 21¼ miles from Oxford, was opened in 1855 in connection with the Chipping Norton branch, its original name being Chipping Norton Junction. Its facilities were increased by the opening of the Bourton-on-the-Water branch in 1862, while in the 1880s the station was completely rebuilt as a five-platform interchange. Kingham is still operative, but the yellow-brick buildings provided as part of the 1880s rebuilding scheme, seen above, have now been replaced by a much smaller station building, seen below. *Inset*: A GWR 'forces leave' third-class return ticket from Kingham to Oxford.

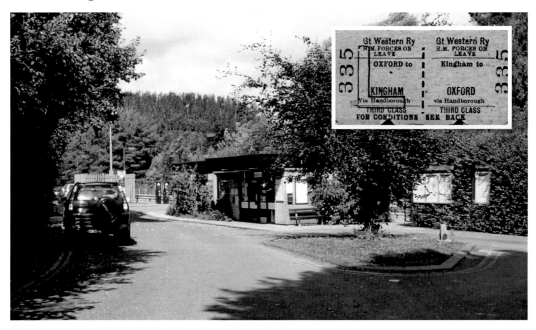

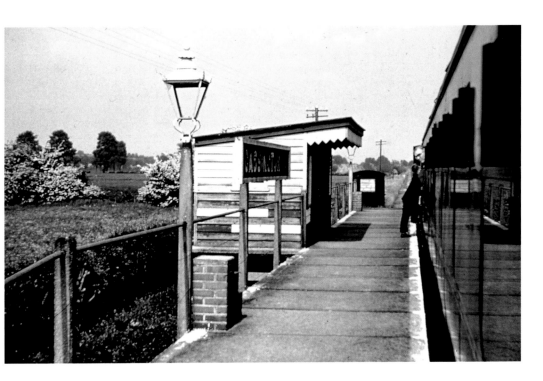

The Witney Branch: Cassington Halt

Cassington Halt, some 5 miles from Oxford, was the first stopping place on the Witney Railway, but it was not an original station, having been opened by the GWR on 9 March 1936. Its modest facilities consisted of a pre-cast concrete platform on the up side of the line, with a wooden shelter for the convenience of waiting passengers. The upper photograph was taken from a train in 1961, while the lower photograph shows the nearby Evenlode Bridge in 1971.

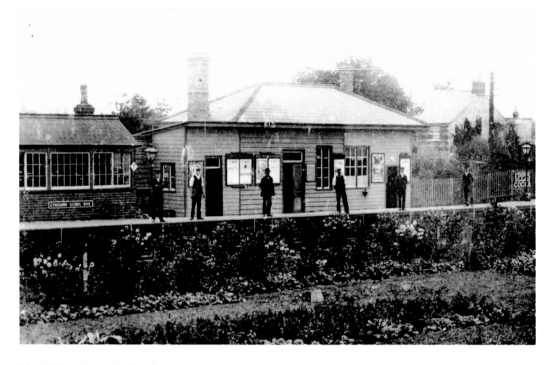

The Witney Branch: Eynsham

When it opened on 14 November 1861, Eynsham, 7¼ miles from Oxford, was the principal intermediate station on the Witney Railway. It originally had just one platform, but a second platform was added in 1944, and Eynsham thereby became a crossing station on the single line. The goods yard, which had three sidings, was on the up side, while the station building was of timber-framed construction. The route of the line through Eynsham has been obliterated by a road scheme.

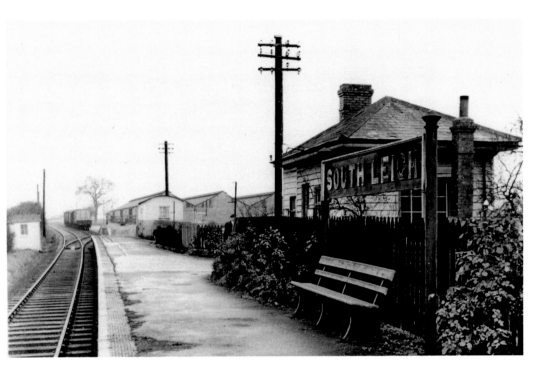

The Witney Branch: South Leigh
South Leigh station (9¼ miles) changed little over the years. When it opened in 1861, this wayside stopping place had consisted of a very short platform on the up side of the line, together with a level crossing and an associated 'gate lodge' or station house. The platform had a length of around 150 feet, although by the end of the nineteenth century it had been extended to 300 feet. There was a single loop-siding on the up side, and the wooden station building, with its low-pitched, pyramidal roof, was clearly in the same architectural 'family' as its counterpart at Eynsham. The upper picture shows the station in the early 1960s, looking west towards Witney, while the photograph to the right depicts villagers awaiting a seaside excursion train in 1933. Those present are, from left to right: Eileen Green, Vera Green, Alice Langford, Sarah Green and Frances Langford.

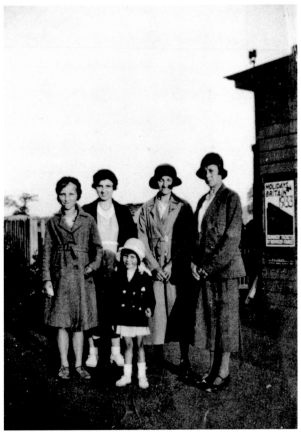

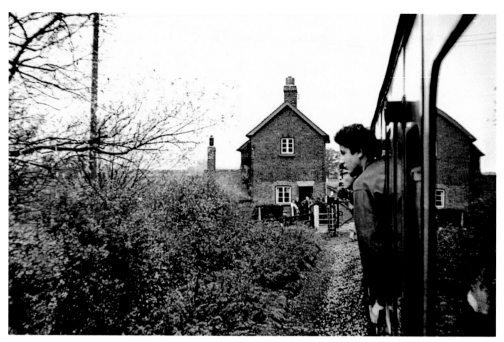

The Witney Branch: South Leigh

South Leigh was one of the few places on the Witney branch that was not served by a competing motor bus service during the twentieth century and, for this reason, its passenger traffic remained relatively healthy. In the early 1900s the station issued about 6,000 tickets per annum. A total of 6,043 tickets were sold in 1903, while 6,092 were sold in 1913, and 5,945 in 1923. Regular passenger services were withdrawn from the Witney line on Saturday 16 June 1962, but freight was carried until 1970. The upper picture shows South Leigh level crossing on 31 October 1970, the photograph having been taken from the very last passenger train as former railwayman Bill Mitchell prepares to close the gates for the last time. The colour photograph, taken in 2012, shows the erstwhile station house. The position of the old level crossing is marked by a slight 'hump' in the roadway.

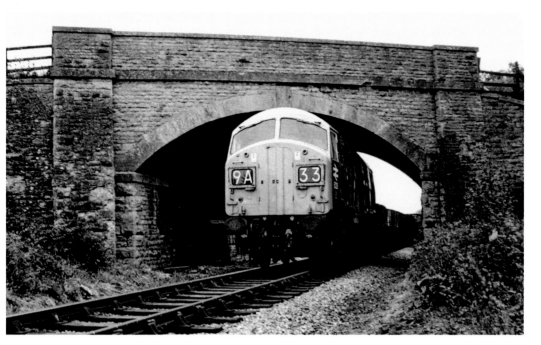

The Witney Branch:
The Ballaso Bridge

Continuing westwards, the railway skirted an old ballast pit known as the Ballast Hole. Here, 10½ miles from Oxford, the line passed beneath a handsome, stone-arched overbridge known as the Ballaso Bridge. This substantial structure, which was built on a skewed alignment, was not entirely of stone construction; it incorporated a brickwork arch, although this was not immediately apparent to the casual observer. The Ballaso was clearly designed to accommodate two lines of rails, its single span having a width of 24 feet 8 inches. The upper picture shows class '22' diesel locomotive No. D6326 hurrying beneath the bridge with a lengthy train of open wagons in the summer of 1970, while the lower photograph is looking eastwards from the parapet of the bridge in 2012. Modern agriculture has virtually obliterated the railway and the Ballaso Bridge is totally obscured by ivy and rampant vegetation.

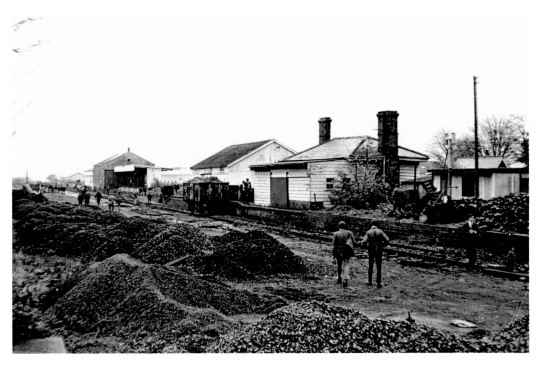

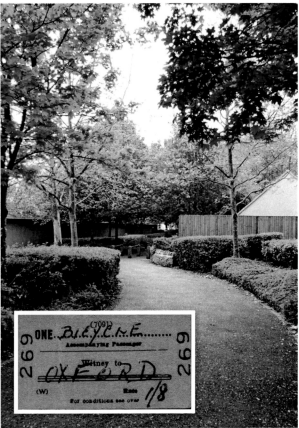

The Witney Branch:
The Old Terminus

When it first opened from Yarnton Junction to Witney on Wednesday 13 November 1861, the Witney Railway terminated at a small station near the parish church. On 15 January 1873, this was replaced by a new station on the East Gloucestershire Railway's Fairford extension, and the old terminus became part of an enlarged goods yard. Above is the original station on 31 October 1970, with the old passenger station in the foreground and the goods shed visible in the background. The people in this image have just arrived on the Witney Wanderer excursion, the last passenger train to run on the Witney Railway. Below is the view from roughly the same vantage point in 2012. The 1861 station has been obliterated by the construction of a supermarket. *Inset*: A BR bicycle ticket from Witney to Oxford, issued on 9 October 1964.

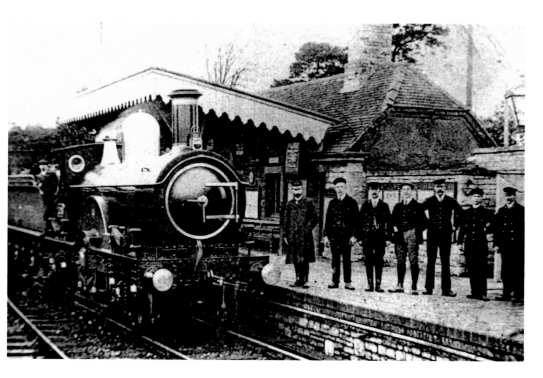

The Witney Branch: Witney Passenger Station

A postcard view of Witney 'New' Station (12 miles), which was opened on 15 January 1873. It shows the station building on the up platform and the crossing loop that enabled up and down trains to pass each other on the single line. Much of the railway has now been replaced by industrial units, one of these new buildings being shown in the lower photograph. The hedgerow visible to the right of the building delineates the site of the former down platform.

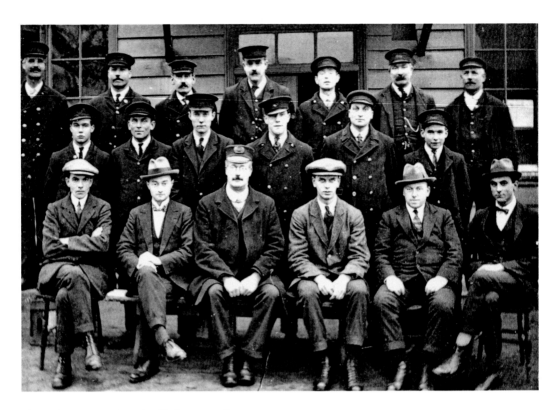

The Witney Branch: A Staff Photograph

Above, Witney station staff members pose for the camera in front of the old Witney Railway station building during the 1920s. Mr Pugh the stationmaster is clearly discernible amid the ticket clerks in the front row. The tall man in the back row is long-serving signalman 'Cis' Bustin. Much of the railway at Witney has been obliterated by the ubiquitous industrial units, but in places the abandoned line has reverted to nature, as at the pretty spot seen below.

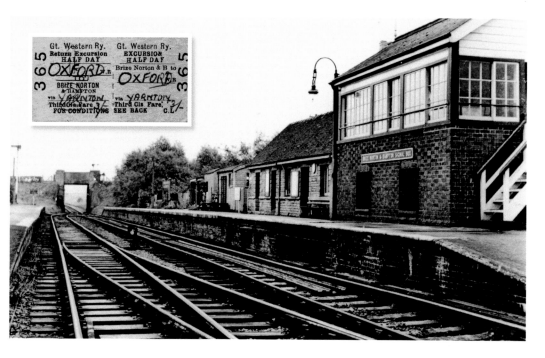

The Witney Branch: Brize Norton & Bampton

Bampton station (15¾ miles) was opened on 15 January 1873. Its name was changed to Brize Norton & Bampton in 1940, reflecting the importance of nearby Brize Norton Aerodrome. Up and down platforms were provided, the main station building being on the down side. The goods yard contained two goods sidings, one of which served the goods shed and loading bank while the other was used for wagon traffic. Seen below, the site is now an industrial estate. *Inset*: A GWR half-day excursion ticket from Brize Norton & Bampton to Oxford, issued on 23 March 1960.

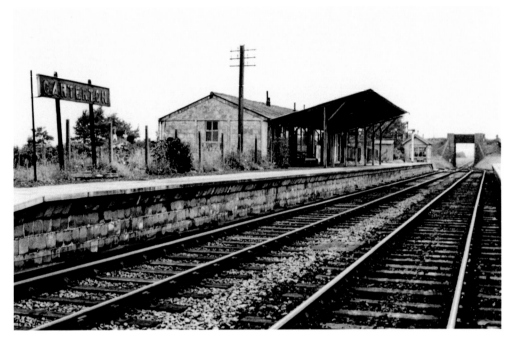

The Witney Branch: Carterton

Carterton (17 miles) was opened on 2 October 1944 to serve the adjacent aerodrome. Its facilities comprised up and down platforms on either side of a crossing loop, with a War-Department-style station building on the up side. The station building featured an asbestos-covered canopy that extended along the entire platform frontage. Internally, this typical wartime structure provided the usual booking office, waiting room and toilet accommodation. Although unsightly, the building was surprisingly spacious and as such it was ideally suited for dealing with large numbers of servicemen. There was no goods yard as the station was intended exclusively for passenger use; nevertheless, there was a considerable traffic in garden produce from neighbouring smallholdings, which was despatched as parcels. The station was closed on 16 June 1962 and after a long period of dereliction it was converted into a riding stable as shown in the lower illustration.

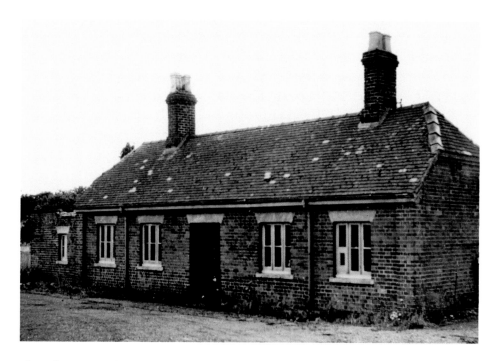

The Witney Branch: Alvescot

Alvescot station, 17¾ miles from Oxford, was only a short distance further on; indeed it could be clearly seen from the platforms at Carterton. The station building, shown in the upper photograph, was built of red brick, although other stations on the East Gloucestershire line were of stone construction. The station closed on 16 June 1962 and the site is now occupied by a nondescript group of buildings. However, the former stationmaster's bungalow still survives, seen below. *Inset*: A child's GWR first-class return ticket from Alvescot to Carterton.

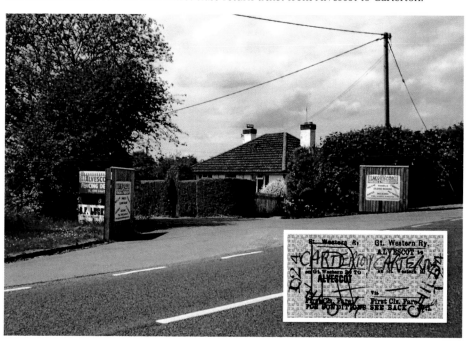

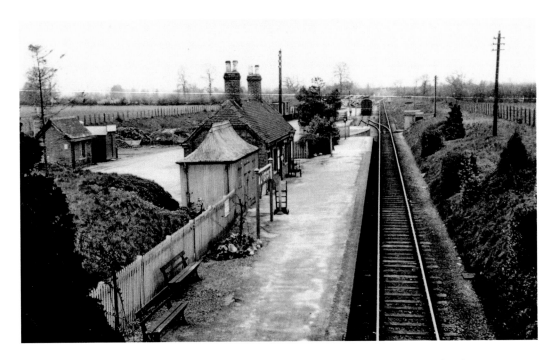

The Witney Branch: Alvescot

These contrasting views look westwards from the road overbridge. The upper view, dating from around 1962, shows the single platform on the down side of the running line, while the colour photograph was taken in 2012. When it first opened on 15 January 1873, Alvescot had been equipped with just one loop-siding for goods traffic, but a second siding was added around 1890. Both of these sidings were sited to the west of the passenger station on the down side. The main loop-siding could accommodate around twenty-five goods vehicles, while the dead-end mileage siding could hold another twenty-six wagons. Alvescot's Victorian stationmaster, Arthur Smith, was in charge for a period of over thirty years – from 1873 to 1907. In the late 1930s the stationmaster was W. C. Collett, who retired in 1944.

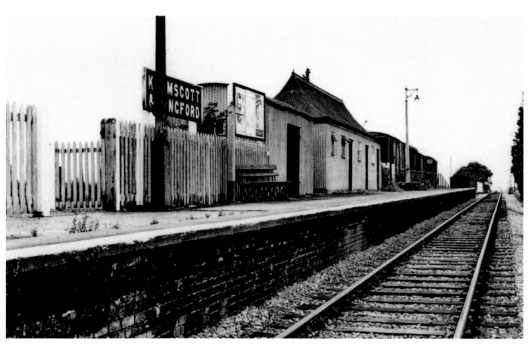

The Witney Branch: Kelmscott & Langford

Kelmscott & Langford station (20¾ miles) was opened on 4 November 1907. It was originally a passenger-only stopping place, although a goods siding was added in 1928. The station was little more than a staffed halt, with a 300-foot brick-faced platform on the down side. The station building was an austere, corrugated-iron pagoda shed. It was staffed by just one man, who was graded as a 'class five stationmaster'. The station issued around 5,000 tickets per year between 1908 and 1959, while goods traffic was around 1,700 tons per annum – some 1,885 tons being handled in 1929, while the corresponding figures for 1933 and 1934 were 1,725 tons and 1,931 tons respectively. The line continued westwards beyond Kelmscott and, having crossed the county boundary, trains called at Lechlade before reaching their terminus at Fairford in neighbouring Gloucestershire. Kelmscott Bridge is seen here in 2012.

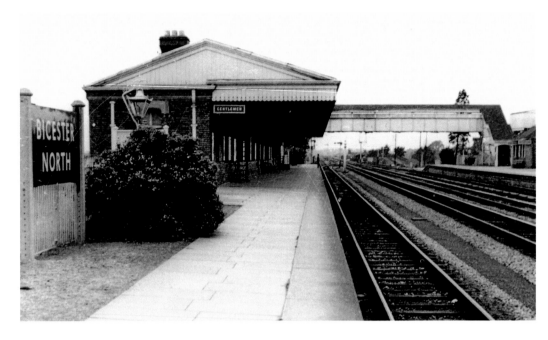

The Bicester Cut-Off: Bicester North

In its present form the Great Western & Great Central Joint Line runs from Marylebone to Aynho Junction, but Chiltern-Line services continue northwards to Birmingham and beyond. Much of the route is in Buckinghamshire, but the line enters Oxfordshire near Blackthorn. Bicester North station, 54¾ miles from Marylebone, was opened on 1 July 1910, its GWR buildings being typical of the period. The upper view dates from around 1963, while the lower view showing class '168' unit No. 168110 was taken in 2012.

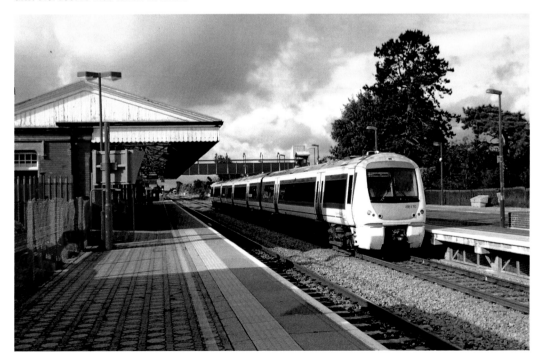

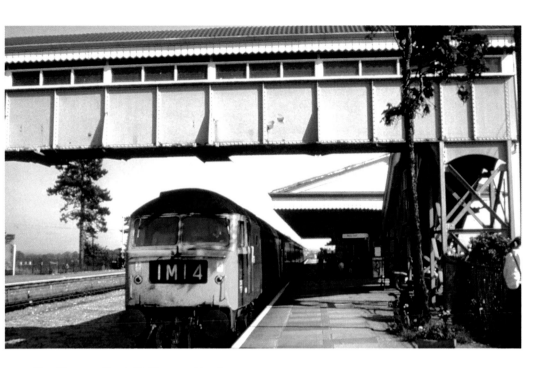

The Bicester Cut-Off: Bicester North

The line through the station was formerly quadruple tracked for a distance of about a mile. However, the railway was singled in 1968 and the up and down fast lines were lifted, leaving a very wide gap between the platforms, as shown in this picture from around 1971. The double track through Bicester was reinstated in 1998–2002, and the 2012 photograph reveals that the up platform, which is designated platform 2, has now been widened. The two platform lines are signalled for bi-directional working.

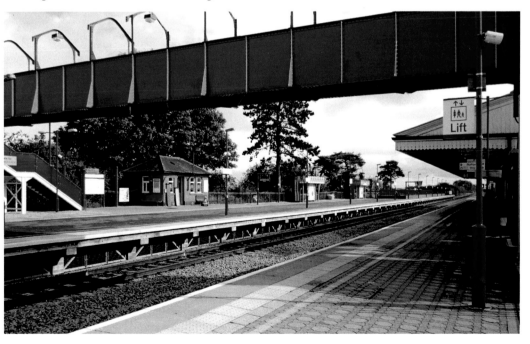

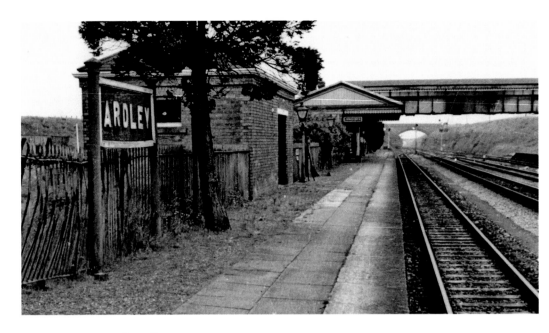

The Bicester Cut-Off: Ardley

Ardley station was similar to Bicester. Its facilities included a four-track layout, with a brick station building and a four-siding goods yard on the up side. Facilities on the down platform comprised a small waiting room and a standard GWR hip-roofed signal cabin. The station was closed on 5 January 1963, but the signal cabin and loops were retained until the singling of the line in 1968. The recent photograph, by Martin Loader, shows class '172' unit No. 172103 at Ardley in 2012.

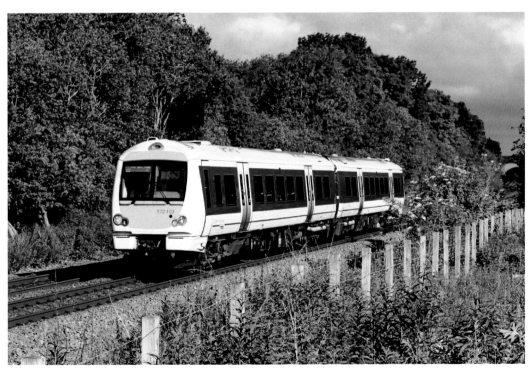

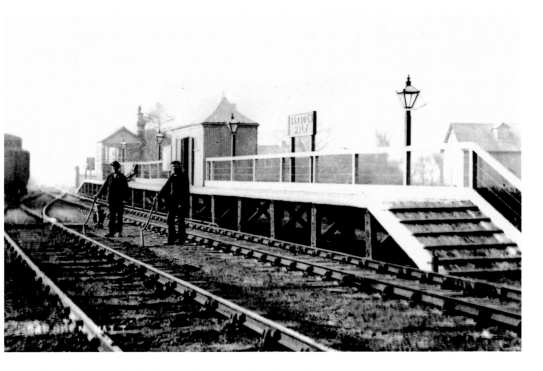

The Banbury & Cheltenham Direct Line: Sarsden Halt

The Banbury & Cheltenham Direct line was a cross-country route that extended across the Cotswolds *via* Kingham. The Kingham to Chipping Norton section was opened on 10 August 1855 and at first there were no intermediate stations, although Sarsden Halt, above, was opened on 2 July 1896. It had a single platform, a pagoda shelter, and a loop-siding for goods traffic. Little now remains, the site of the level crossing being marked by a slight 'hump' in the roadway, as seen in the photograph below.

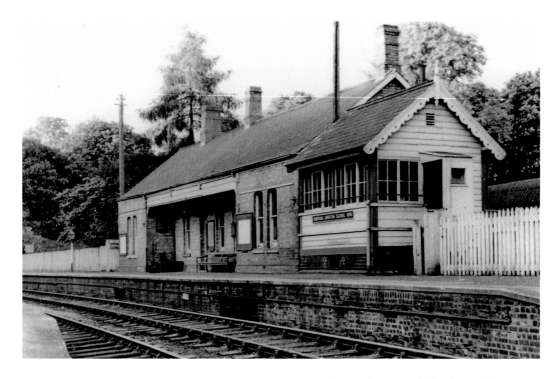

The Banbury & Cheltenham Direct Line: Chipping Norton

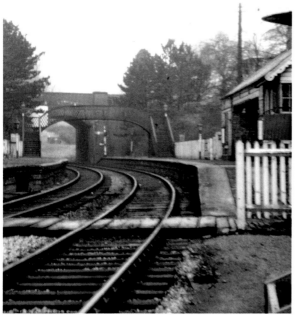

When it first opened in 1855, Chipping Norton was the terminus of a 4½-mile branch from Kingham, but on 16 April 1887 the line was extended eastwards to Kings Sutton. A new station was opened at Chipping Norton, and the old terminus become part of an enlarged goods yard. The new station had slightly curved platforms on either side of a crossing loop, and the main station building was on the up side. Above is a detailed view of the station building around 1963. To the left is a general view of the station, looking north-eastwards towards Banbury around 1958. The Chipping Norton to Kings Sutton section lost its passenger service on 2 June 1951, but freight trains continued until 1958, when the line was blocked by a landslide. Goods trains served Rollright until 1962, when Chipping Norton became the end of the line. *Inset*: A GWR third-class single ticket from Chipping Norton to Adlestrop, issued on 18 December 1963.

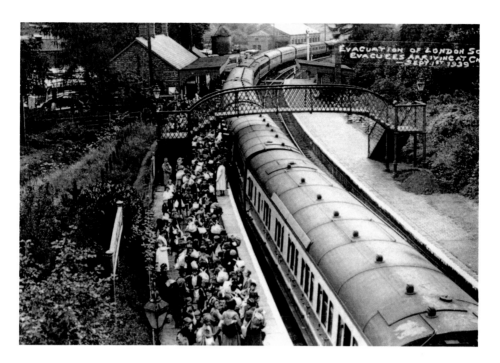

The Banbury & Cheltenham Direct Line: Chipping Norton

Like Culham, Chipping Norton became a reception station during the September 1939 London Evacuation Scheme, as seen in the above image. In this capacity it handled three twelve-coach trains, each carrying 800 passengers – a total of 2,400 evacuees. Other local reception stations included Oxford, Banbury, Henley-on-Thames, Cholsey, Witney and Bicester North. Below is the station approach in 2012. Chipping Norton station was closed on Saturday 1 December 1962 and the site is now an industrial estate.

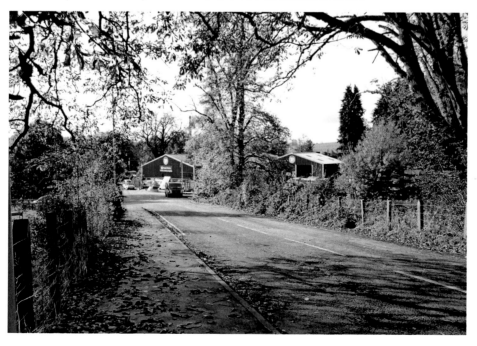

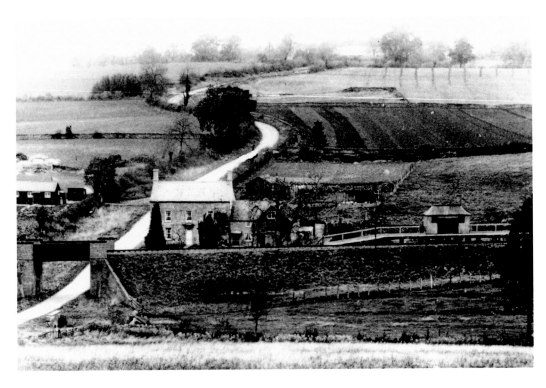

The Banbury & Cheltenham Direct Line: Rollright Halt & Halt Farm

Rollright Halt, 7½ miles from Kingham, was opened on 12 December 1906. Its facilities were similar to those at Sarsden: there was a sleeper-built platform and pagoda shelter for passenger traffic, together with a loop-siding for coal and wagon load traffic. At night, the lonely platform was lit by oil lamps, which were lit and trimmed by the guards of passing trains. The girder bridge to the west of the halt has been dismantled, but the overgrown embankments remain, as seen below.

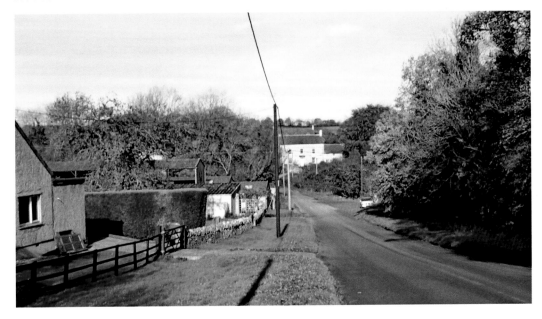

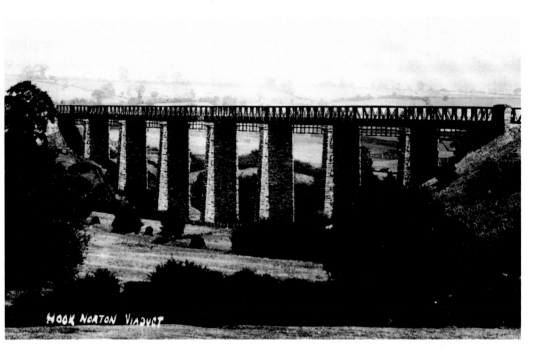

HOOK NORTON VIADUCT

The Banbury & Cheltenham Direct Line: Hook Norton Viaducts

As eastbound trains approached Hook Norton, they passed over two closely spaced viaducts. Hook Norton No. 2 Viaduct, seen above, had eight lattice girder spans, the horizontal girders being supported on seven gently tapering stone columns, while the neighbouring No. 1 Viaduct was slightly shorter, with five spans. The viaducts were dismantled shortly after closure and there was genuine sadness when these mighty structures were brought crashing down. The viaducts 'took two hundred men nearly two years to build and cost two men's lives', lamented the *Oxford Mail*, but it took 'four Scotsmen just a few weeks to demolish them'. In fact, the demolition was only part completed, the object of the exercise being the recovery of many hundreds of tons of scrap metal. The great stone pillars were left *in situ* (*right*) and, as the *Oxford Mail* remarked, they remain as a tribute to the workmanship of their Victorian builders.

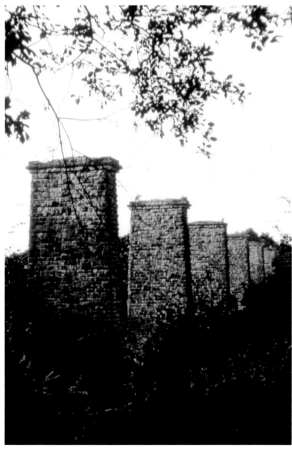

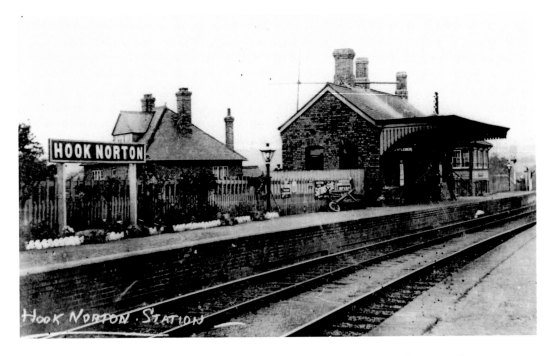

The Banbury & Cheltenham Direct Line: Hook Norton Station and the Railway Hotel

Hook Norton, the next station (11 miles), was opened in 1887. Its track layout comprised up and down platforms and a crossing loop. The station buildings and goods yard were on the up side, while further sidings were available for ironstone traffic on the down side of the line. The road from Hook Norton to Milcombe passed beneath the line *via* an underline bridge at the Banbury end of the station. The station has now been dismantled; however, the former Railway Hotel survives, as seen below.

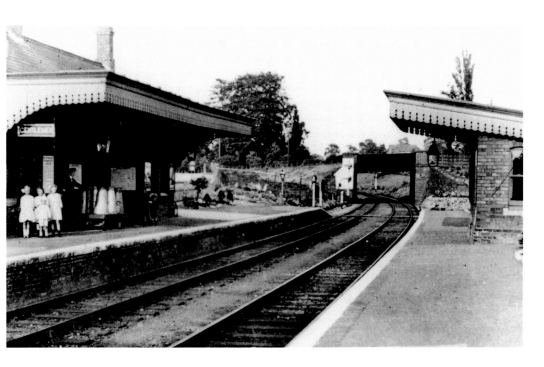

The Banbury & Cheltenham Direct Line: Bloxham

Bloxham (15½ miles) incorporated up and down platforms and a crossing loop with a two-siding goods yard on the up side. The station building, of identical appearance to its counterpart at Hook Norton, was on the up platform, and there was a waiting shelter on the down side. The A361 road was carried across the line on a skew-girder bridge at the east end of the station. The station site is now occupied by houses and a playing field.

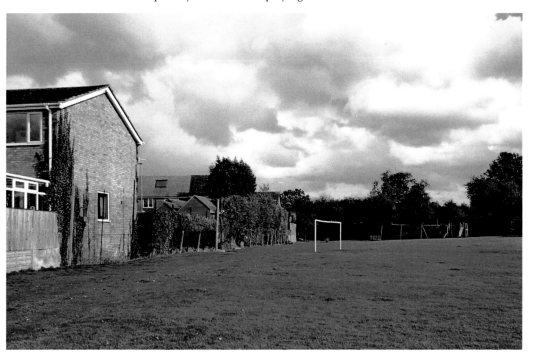

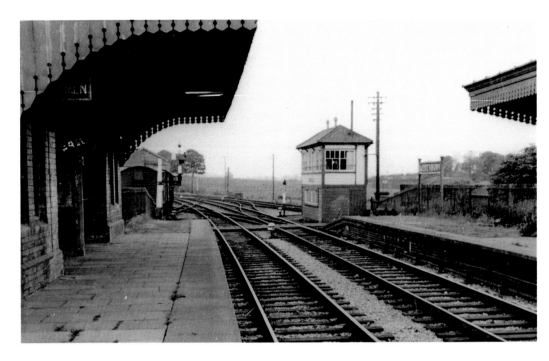

The Banbury & Cheltenham Direct Line: Adderbury

Still heading eastwards, the route continued to Adderbury (18¼ miles). This station resembled the other stopping places between Kingham and King's Sutton, its brick station building and goods shed being more or less identical to those at Hook Norton and Bloxham. Adderbury lost its passenger services in 1951 but goods traffic continued until 1969. The upper picture shows the station around 1962, while the colour view shows the industrial estate that has now been built on the station site.

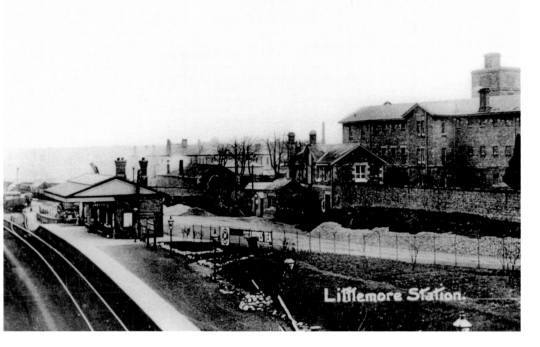

Littlemore Station.

The Oxford to Princes Risborough Line: Littlemore

The line between Princes Risborough and Oxford was opened as a north-westwards extension of the Wycombe Railway from High Wycombe to Thame on 1 August 1862. It was completed through to Kennington Junction near Oxford on 24 October 1864. In 1910 the line was relegated to secondary status when main-line services were diverted onto the newly opened Bicester Cut-off route between Princes Risborough and Aynho Junction. Littlemore, 3½ miles from Oxford, was a single-platform station, with standard GWR station buildings. There were several goods sidings, including a rail link to the County Lunatic Asylum that left the goods yard by means of a wagon turntable. The above old postcard view of Littlemore station looks east towards Princes Risborough around 1912; the asylum can be seen to the right of the picture. Right is a closer view of the station building from around 1963, with the goods yard visible in the background.

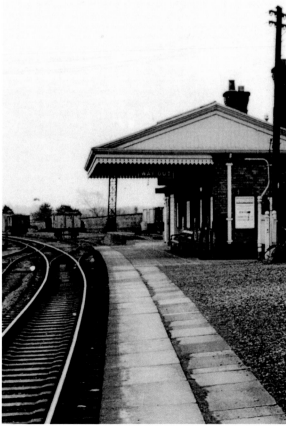

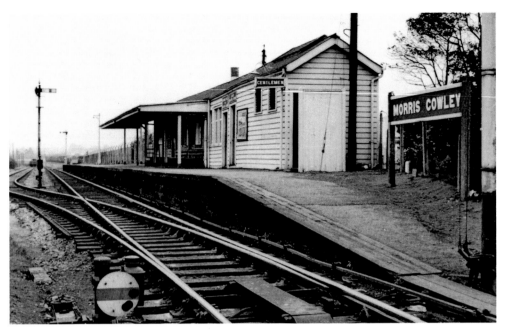

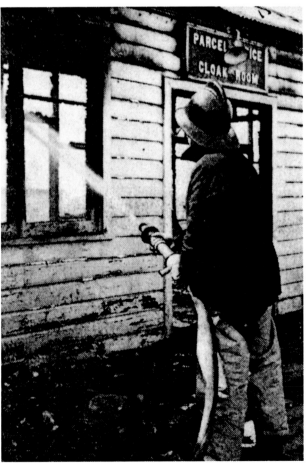

The Oxford to Princes Risborough Line: Morris Cowley

The upper view shows Morris Cowley station during the 1960s. This station, which was 4¾ miles from Oxford, was opened on 24 September 1928. As its name implies, it served the adjacent Morris Motors car factory. Confusingly, Morris Cowley station occupied the site of an earlier halt known as Garsington Bridge, which had been opened on 1 February 1908, and closed as a wartime economy measure in 1915. Passenger services were withdrawn from Morris Cowley and the other intermediate stopping places between Oxford and Princes Risborough on Sunday 6 January 1963, although freight trains continued to run to Morris Cowley in connection with the car factory. Sadly, the wooden station building was destroyed by fire, seen left, and the line was later severed between Morris Cowley and Thame.

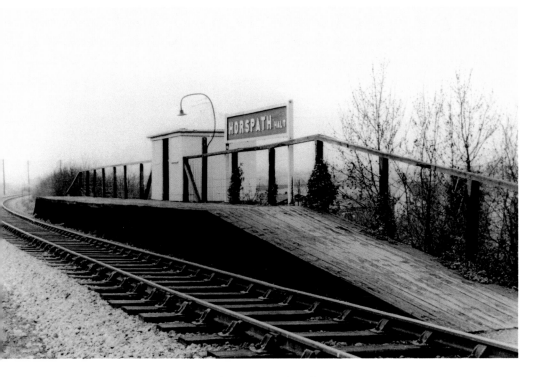

The Oxford to Princes Risborough Line: Horspath Halt

Horspath Halt, to the east of Morris Cowley, had a chequered history. It opened on 1 February 1908, closed in March 1915, reopened on 5 June 1933 and finally closed on 6 January 1963. The wooden platform, with its GWR pagoda shelter, was perched somewhat precariously on the side of an embankment, as shown in the lower photograph. The embankment can still be seen, but this section of the railway has been dismantled, and nothing remains of the sleeper-built halt.

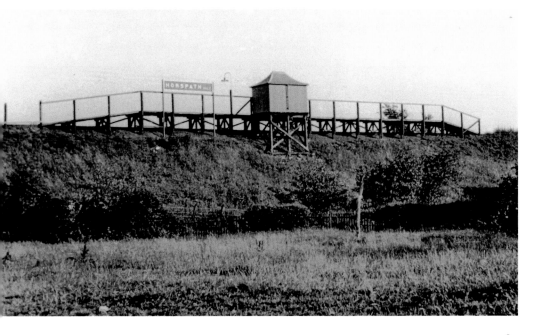

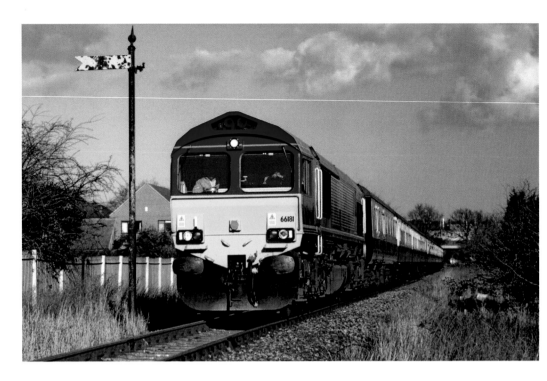

The Oxford to Princes Risborough Line: Wheatley

Above, class '66' locomotive No. 66181 hauls a railtour along the still extant branch to Morris Cowley. Seen below, Wheatley (7¾ miles), on the closed section of the line, featured up and down platforms. The main station building and two-siding goods yard were on the up side, while the signal box was sited to the east of the station on the down side. The station building was an original Wycombe Railway structure that dated back to the opening of the line in 1864.

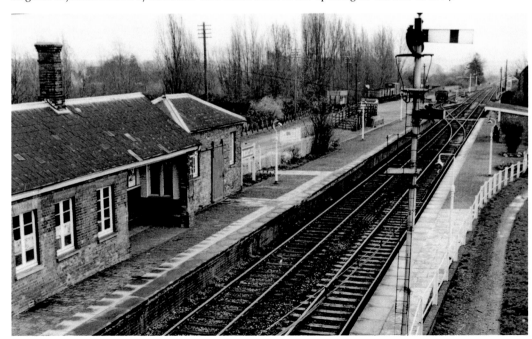

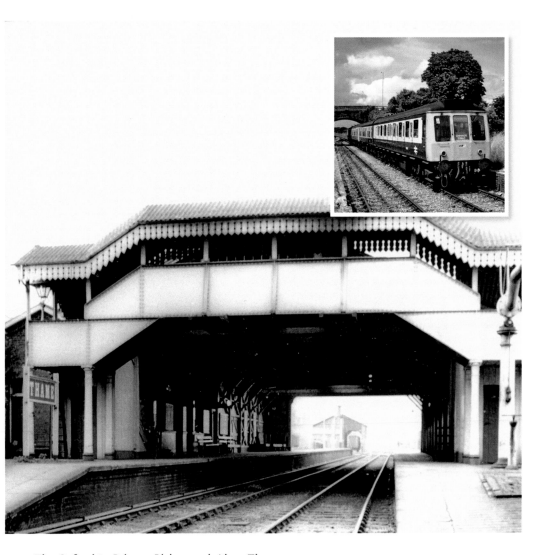

The Oxford to Princes Risborough Line: Thame

Thame, the principal intermediate station between Princes Risborough and Oxford (15¼ miles), was a passing station, with up and down platforms on either side of a crossing loop, its main station building being sited on the up side. Sidings were available on both sides: the main goods yard, with its characteristic Brunel-style goods shed, was on the up side, while an additional loading dock was provided at the rear of the down platform. The station buildings were of Wycombe Railway vintage, but the most impressive feature of the station was its gable-roofed train shed, a classic Brunelian design. The up and down platforms were linked by a covered footbridge at the west end of the train shed. Thame lost its passenger services on 6 January 1963, but on 9 July 1988, the four multiple-unit vehicles of the Chinnor Tonic railtour, including class '115' vehicle No. 51652 (*inset*), were among the last passenger trains to visit the station. Although the Oxford to Princes Risborough route was severed between Morris Cowley and Thame, at the eastern end of the line trains still ran from Princes Risborough to an oil-linked rail terminal at Thame. Unfortunately, this welcome source of bulk freight traffic came to an end with the completion of an oil pipeline, and the last train left Thame on 17 April 1991 behind class '47' locomotive No. 47295. The rails and platforms have now been replaced by a road and an industrial estate.

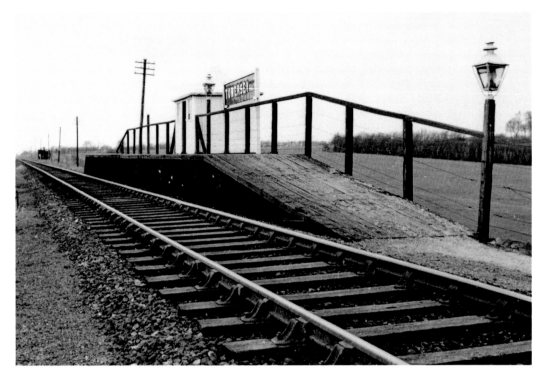

The Oxford to Princes Risborough Line: Towersey Halt

Opened on 5 June 1933, Towersey Halt (16½ miles) was very similar to neighbouring Horspath Halt. Both of these unstaffed stopping places had sleeper-built platforms and characteristic GWR pagoda shelters. The halt was sited on the side of an embankment, in convenient proximity to Towersey village. It was closed on 6 January 1963.

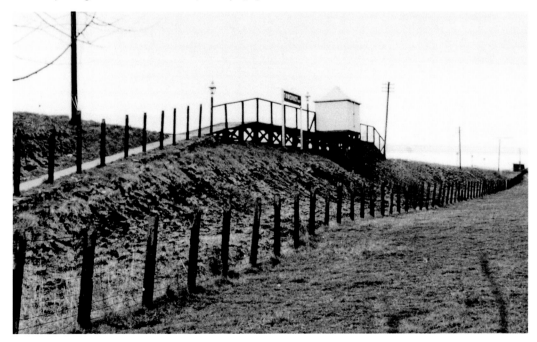

The Chinnor & Princes Risborough Railway: Chinnor & Watlington

The Watlington & Princes Risborough Railway was incorporated on 26 July 1869, and the line was opened from Princes Risborough to Watlington, a distance of 8 miles 69 chains, on 15 August 1872. In 1883 the undertaking was purchased by the GWR and the railway became a GWR branch line with a service of around four trains each way. After an uneventful life, the line was closed to passengers on 29 June 1957. Goods traffic lingered on until 1961, when freight services were withdrawn between Chinnor and Watlington. The route survived as far as Chinnor cement works, the main source of traffic being coal for the rotary kilns. This traffic lasted until the 1980s, but on 20 December 1989 class '47' diesel locomotive No. 47258 worked the last trainload of coal from Newport Alexandra Docks to Chinnor. Following the demise of freight services, the Chinnor to Princes Risborough line was identified as a candidate for preservation. By the end of 2000, the Chinnor & Princes Risborough Railway was operating over 3 miles of line between Chinnor and Thame Junction, although trains were unable to run into the bay platform at Princes Risborough. The upper photograph shows Watlington station, while the lower picture shows Chinnor; both of these old postcards date from around 1912.

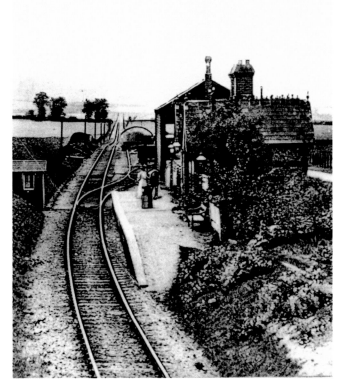

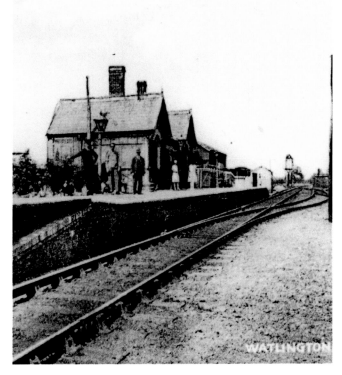

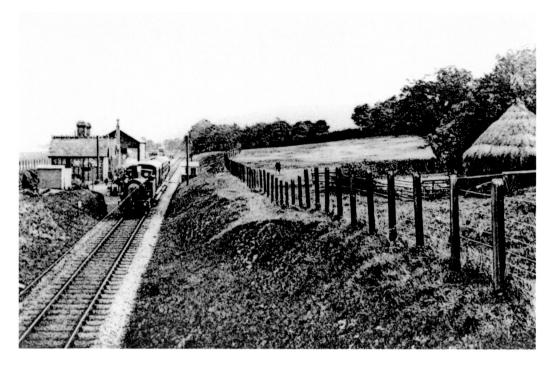

The Chinnor & Princes Risborough Railway: Aston Rowant

Aston Rowant station, 2¾ miles from Watlington, was a single-platform station with a small goods yard. The station buildings on the Watlington branch were built to the familiar and serviceable 'H-plan', with a central block flanked by two gabled cross-wings, as shown in these contrasting views of Aston Rowant, both of which look north-east towards Princes Risborough. The upper photograph dates from around 1905, while the lower view was taken in the 1960s.

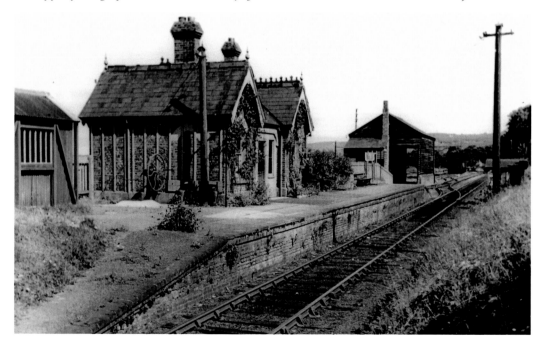

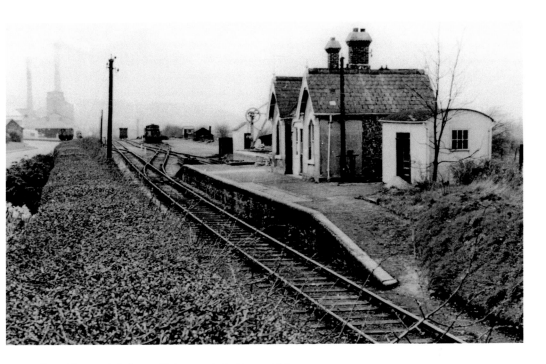

The Chinnor & Princes Risborough Railway: Chinnor

Chinnor station around 1960, with the cement works partly obscured by haze. Cement manufacturing at Chinnor commenced in 1919, and the cement works subsequently developed into a major complex; its 175-foot-high chimneys were visible for miles around. Chinnor station was demolished after closure, but in 1998 work began on the construction of a new station building, the still-extant building at Watlington being used as a model for this entirely new structure. The colour photograph shows '57XX' class 0-6-0PT No. 5786 beside the reconstructed station.

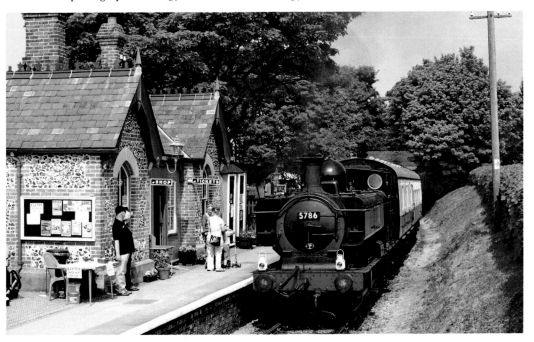

SINGLE LINE. Worked by Train Staff and only one engine in steam at a time, or two coupled together. Form of Staff, Round. Colour, Black.
Passenger Trains to carry " B " Headlamps. Freight Trains to carry one Headlamp in centre of buffer plank.

Week Days only.

Down Trains.

Distance M.	C.	STATIONS		Ruling Gradient 1 in	Point to point times	Allow for Stop	Allow for Start	Freight ¶	Empty Auto.	Passenger	Freight SX	Passenger SO	Passenger	Freight SO	Passenger	Passenger	Freight RR
					Mins.	Mins.	Mins.	a.m.	a.m.	a.m.	p.m.	p.m.	p.m.	p.m.	p.m.	p.m.	p.m.
—	—	Princes Risborough	dep.	—	—	—	1	5 30	7 57	10 22	12 20	12 40	1 55	3 55	5 48	8 2	10 45
1	52	Bledlow Bridge Halt	,,	107 F.	—	—	1	—	—	10 27	—	12 45	2 0	...	5 53	8 7	—
2	75	Wainhill Halt	,,	68R.	—	—	—	—	—	10 30	—	12 48	2 3	...	5 56	8 10	—
3	57	Chinnor	,,	68R.	12	1	1	Q	CR	10 33	12 34	12 51	2 6	4 9	5 59	8 13	—
5	17	Kingston Crossing Halt	,,	61 R.	—	—	—	—	—	10 37	—	12 55	2 10	...	6 3	8 17	—
6	16	Aston Rowant	,,	116 R.	8	1	1	6 35	CR	10 40	...	12 58	2 13	...	6 6	8 20	CR
7	4	Lewknor Bridge Halt	,,	117 F.	—	—	—	—	—	10 43	...	1 1	2 16	...	6 9	8 23	—
8	75	Watlington	arr.	78 F.	8	1	—	6 45	8 20	10 48	...	1 6	2 21	...	6 14	8 28	11 15

¶—May convey passengers from Princes Risborough when required. Q Aston Rowant arrive 5.52 a.m.

Up Trains.

STATIONS		Ruling Gradient 1 in	Point to point times	Allow for Stop	Allow for Start	Freight	Passenger	Passenger	Passenger	Freight SX	Passenger SO	Passenger	Freight SO	Passenger	Freight RR Z
			Mins.	Mins.	Mins.	a.m.	a.m.	a.m.	a.m.	p.m.	p.m.	p.m.	p.m.	p.m.	p.m.
Watlington	dep.	—	—	—	1	4 20	7 25	8 42	11 30	—	1 15	3 10	—	7 15	8 50
Lewknor Bridge Halt	,,	78 R.	—	—	—	—	7 30	8 47	11 35	...	1 20	3 15	...	7 20	—
Aston Rowant	,,	117 R.	8	1	1	—	7 33	8 52	11 38	...	1 23	3 18	...	7 23	9 20
Kingston Crossing Halt	,,	116 F.	—	—	—	—	7 36	8 55	11 41	...	1 26	3 21	...	7 26	—
Chinnor	,,	61 F.	8	1	1	—	7 40	9 0	11 45	1 18	1 30	3 25	4 55	7 30	CR
Wainhill Halt	,,	68 F.	—	—	—	—	7 43	9 3	11 48	...	1 33	3 28	—	7 33	—
Bledlow Bridge Halt	,,	68 F.	—	—	—	—	7 46	9 6	11 51	—	1 36	3 31	—	7 36	—
Princes Risborough	arr.	107 R.	10	1	—	4 48	7 51	9 11	11 56	1 30	1 41	3 36	5 5	7 41	9 40

Z Aston Rowant arrive 9.0 p.m.

The Chinnor & Princes Risborough Railway: The 1946 Timetable

Above, the May 1946 timetable shows up trains from Watlington at 7.25 a.m., 8.42 a.m., 11.30 a.m., 3.10 p.m. and 7.15 p.m., and down workings from Princes Risborough at 10.22 a.m., 1.55 p.m., 5.48 p.m. and 8.02 p.m. The single line was worked by train staff on the 'one-engine-in-steam' system. The present-day photograph below, taken by Mike Marr, shows BR Standard class '4MT' 2-6-4T locomotive No. 80072 at Chinnor in October 2012.

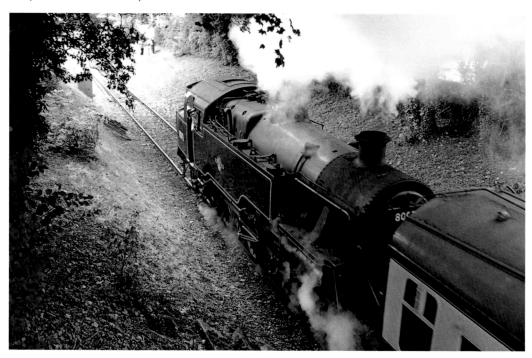

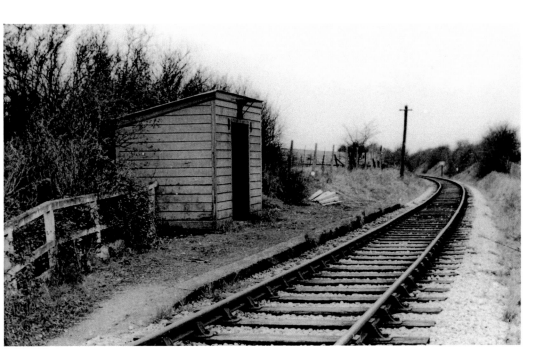

The Chinnor & Princes Risborough Railway: Lewknor Bridge & Wainhill Crossing Halt

A number of halts were added in 1906, including Lewknor Bridge (*above*), which had a very low platform and a simple waiting shelter for the convenience of occasional travellers. Wainhill Crossing Halt, originally opened in 1926, has been reconstructed by the Chinnor & Princes Risborough Railway. This colour photograph shows class '17' diesel locomotive No. D8568 approaching the rebuilt halt, which is not yet open for public traffic.

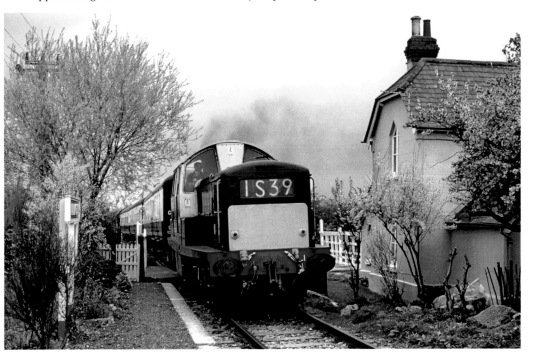

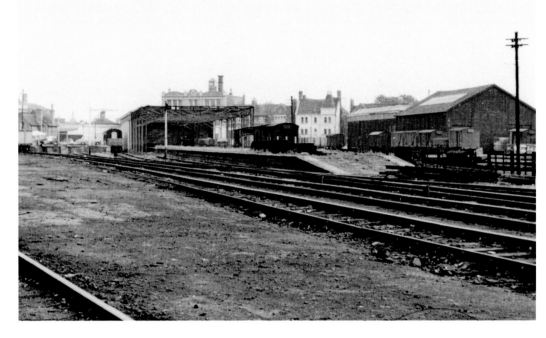

The Buckinghamshire Railway: Oxford Rewley Road

Oxfordshire was, in effect, part of the GWR heartland, and the Buckinghamshire branch of the L&NWR was in many ways a 'foreign' intruder. Oxford Rewley Road terminus, which was sited alongside the GWR station, opened on 20 May 1851. Its prefabricated components were identical to those employed on the Crystal Palace. As seen below, the site of the station has been extensively redeveloped. The station building has been re-erected at the Buckinghamshire Railway Centre on Quainton Road.

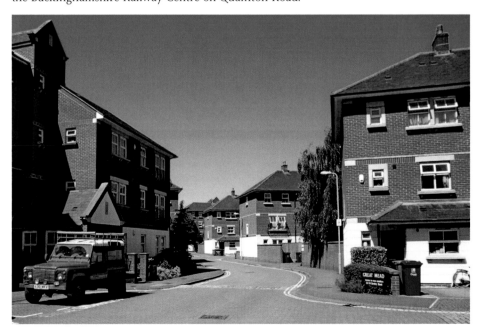

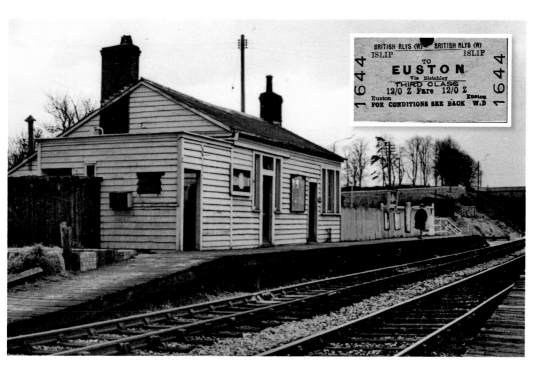

The Buckinghamshire Railway: Islip

At one time there were several small halts between Oxford and Islip, but these were all closed by the LMS in 1926 and, thereafter, Islip (5¾ miles) became the first intermediate stopping place on the cross-country route between Oxford, Bletchley and Cambridge. The station was closed on Saturday 30 December 1967 and reopened on 15 May 1989. Islip was originally a two-platform station with wooden buildings on the down side, but the present layout provides just one platform. The upper picture shows the station in 1968, looking west towards Oxford with both tracks *in situ*, whereas the colour photograph shows the now-singled line in October 2012. Class '165' diesel unit No. 165007 is approaching the platform with the 13.43 eastbound service to Bicester Town. *Inset*: An early BR third-class single ticket from Islip to London Euston.

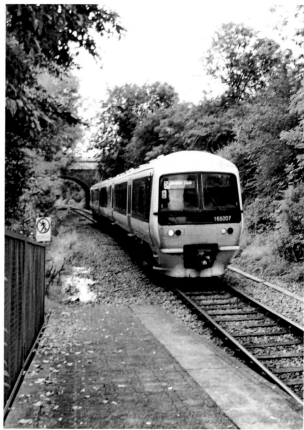

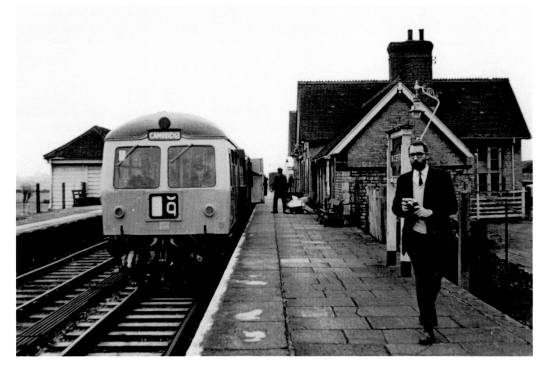

The Buckinghamshire Railway: Bicester London Road

Bicester London Road (11¾ miles) opened on 1 October 1850. The station was known as Bicester London Road to distinguish it from the GWR station, although the name has latterly been changed to Bicester Town. The former L&NWR line lost its passenger services on Saturday 30 December 1967, although a local service was reinstated between Bicester London Road and Oxford in May 1987. The upper view, looking west towards Oxford, provides a glimpse of the station in 1967 – the substantial Cotswold-stone station buildings are clearly visible to the right of the picture. The lower view, in contrast, shows the present rationalised facilities. The track layout has been reduced to the running line and a single dead-end siding, while the station building has been partially demolished, leaving a section of the front wall *in situ*.

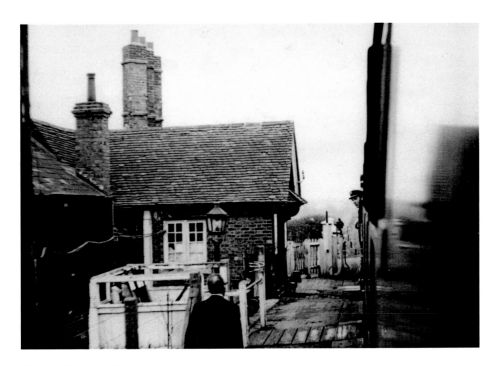

The Buckinghamshire Railway: Launton

The Buckinghamshire Railway crossed the county boundary beyond Launton (14 miles), the remainder of the line to Bletchley being in Buckinghamshire. Opened on 1 October 1850, Launton was a two-platform stopping place with station buildings on the down side and a level crossing to the west. The upper photograph was taken from a train on 30 December 1967, the last day of regular passenger operation, while the colour view shows the station about a year later.

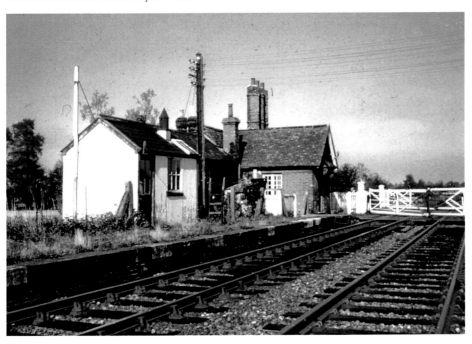

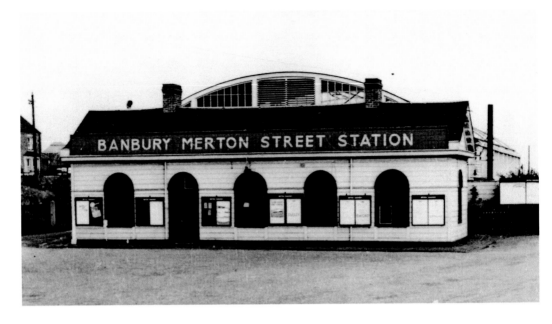

The Buckinghamshire Railway: Banbury Merton Street

Banbury Merton Street was opened on 1 May 1850 as the terminus of a Buckinghamshire Railway branch from Verney Junction on the Oxford to Bletchley route. It featured a central island platform and two terminal roads beneath an arc-roofed train shed. The wooden station buildings were situated at right angles to the terminal buffer stops as shown in this early 1960s photograph, above. Below, a class '4MT' 2-6-4T locomotive is pictured at Merton Street around 1950. The site of this station has been totally redeveloped. *Inset*: A BR Banbury Fair 'control' ticket from Banbury Merton Street, dated 19 October 1956.

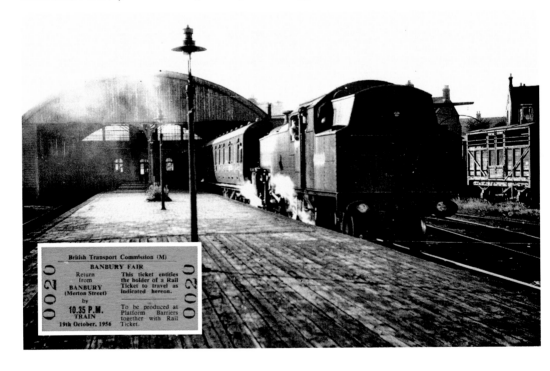

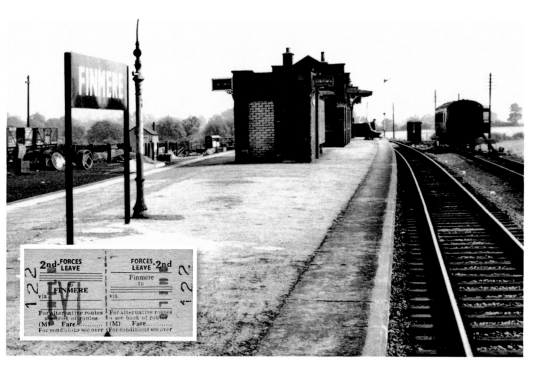

Great Central Railway: Finmere
The GCR's London Extension from Annesley Junction to Marylebone was formally opened on 9 March 1899. Finmere station, 54¼ miles from Marylebone, was something of an anomaly, in that it was one of only two GCR stations in Oxfordshire (the other being Chalcombe Road Halt, to the north of Banbury). The upper picture shows Finmere station in the early 1960s looking south towards Marylebone. Access to the island platform was *via* a flight of covered steps from the busy A421 road, which passed beneath the line at the south end of the station. The GCR main line was closed on 3 September 1966 but the railway bridge still spans the main road as shown in the lower picture, which was taken by Kevin Tobin in October 2012. The red-brick villa that can be seen to the left of the picture was the stationmaster's house. *Inset*:A BR 'forces leave' ticket from Finmere.

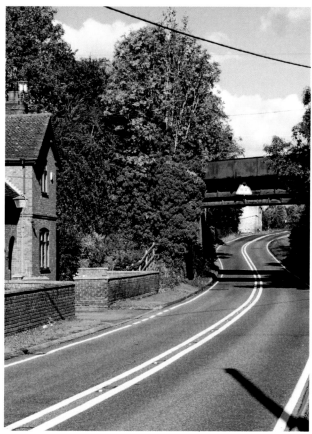

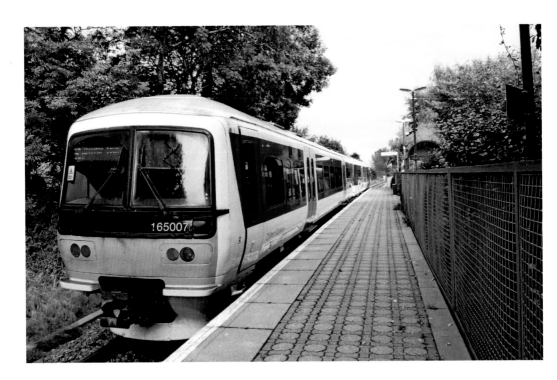

Envoi

Islip station (*above*) was opened in 1850, while Charlbury station, with its distinctive Brunelian station building (*below*), dates from 1853, yet both continue to serve the public in the twenty-first century. Their longevity is a tribute to the energy and vision of the Victorian entrepreneurs who brought the local railway system into existence over 170 years ago.

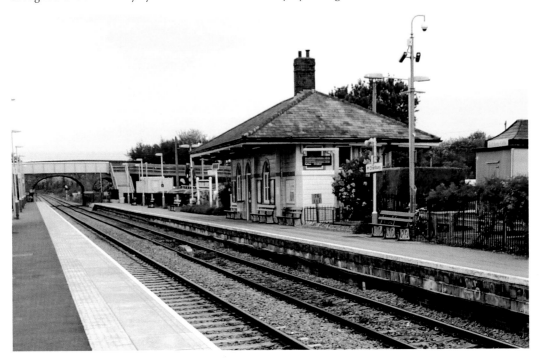